Susan Danly

# TELLING TALES

*Nineteenth-Century Narrative Painting from the Collection of*
*the Pennsylvania Academy of the Fine Arts*

THE AMERICAN FEDERATION
OF ARTS

PENNSYLVANIA ACADEMY
OF THE FINE ARTS

This catalogue has been published in conjunction with *Telling Tales: Nineteenth-Century Narrative Painting from the Collection of the Pennsylvania Academy of the Fine Arts*, an exhibition organized by the Pennsylvania Academy of the Fine Arts with the support of the National Endowment for the Arts, a federal agency. Circulated by the American Federation of Arts, the exhibition is a project of ART ACCESS, a program of the AFA with major support from the Lila Wallace-Reader's Digest Fund.

Published by the American Federation of Arts
41 E. 65 Street, New York, New York, 10021,
and the Pennsylvania Academy of the Fine Arts,
Broad and Cherry Streets, Philadelphia, Pennsylvania 19102

Library of Congress Cataloging-in-Publication Data

Pennsylvania Academy of the Fine Arts
   Telling Tales: nineteenth-century narrative painting from the collection of the Pennsylvania Academy of the
   Fine Arts/Susan Danly
   p.    cm.
     Includes bibliographical references and index.
     ISBN 0-943836-15-8
       1. Narrative painting. American–Exhibitions.    2. Narrative painting–19th century–United States–
     Exhibitions.    I. Danly, Susan.    II. Title.
   ND1451.5.P46    1991
   759.13'074'74811–dc20                                                                            91-7787
                                                                                                      CIP

*Publication Coordinator:* Michaelyn Mitchell
*Designer:* Lawrence Wolfson
*Editor:* Jacolyn A. Mott
*Photographer:* Rick Echelmeyer
*Composition:* Typogram, Inc.

Cover: Detail of *The Peaceable Kingdom* by Edward Hicks

Printed in Hong Kong by South China Printing Co.

# Contents

# GRAND COMBINATION

## OF ATTRACTIONS,

AT THE

## ACADEMY OF FINE ARTS,

### CHESTNUT STREET.

## ROSSITER'S

### GREAT SCRIPTURAL PAINTING

OF THE

# RETURN OF THE DOVE

OR,

## THE TRIUMPH OF FAITH,

A larger and more interesting picture than the Artist's

## RUTH AND NAOMI,

which was so enthusiastically received wherever it was exhibited last year;

PAINTED BY

THOS. PRITCHARD ROSSITER, OF NEW YORK.

Together with the

### Extensive Collection of Works of Art,

## PAINTINGS AND STATUARY,

OF THE

## PENNSYLVANIA ACADEMY;

Among which are

# DEATH ON THE PALE HORSE

AND

## CHRIST HEALING THE SICK,
(by Sir Benj. West.)

## THE DEAD RESTORED,
(by Washington Allston.)

## WASHINGTON,
The Full Length Original, by Gilbert Stewart.

## QUEEN VICTORIA.
(by Sully.)

## JACKSON--BENJAMIN RUSH, and SAMUEL COATES,
(by Sully.)

## HENRY CLAY,
(by Neagle.)

## THE STORM.
(A beautiful piece by Vernet.)

## ST. LAWRENCE,
(by Titian.)

### BATTLE OF THE CENTAURS AND LAPITHÆ.

A large Model Group by Lough; in all several hundred Pictures, Marble Statues, Casts, Works of the old Masters, &c. &c.

The above constitute an exhibition EXCEEDINGLY ATTRACTIVE, and one which cannot fail to interest every visitor.

STRANGERS visiting the city have now (for a mere trifle) an opportunity of viewing a SPLENDID PRODUCTION of one of the most talented of AMERICAN ARTISTS, and many RENOWNED WORKS by the gifted of our own and other days.

OPEN FROM 9 A. M., UNTIL 10 P. M.

☞ BRILLIANTLY ILLUMINATED IN THE EVENING.

### SEASON TICKETS, 50 cents.

Admission to the whole, only 25 cts.     Children, half price.

LIBERAL ARRANGEMENTS MADE WITH SCHOOLS.

☞ For a description of The Return of the Dove to the Ark, and *Notices of the Press*, ☞ TURN OVER.

please

# FOREWORD

Beginning with the acquisition of monumental works painted by important expatriate Americans such as Benjamin West, Washington Allston, and Charles R. Leslie, the Pennsylvania Academy of the Fine Arts introduced narrative painting to American audiences in the early nineteenth century. Through the annual exhibitions at the Academy, the taste for storytelling pictures developed beyond the traditional tales of European history and literature to an interest in "home-grown" subjects. America's early naval victories were celebrated in paintings by Thomas Birch, rural family life in comic scenes by John Lewis Krimmel, and popular literature in genre images by Henry Inman. The Academy's school, which began its formal program of instruction in 1868 under the direction of Christian Schussele, placed great emphasis on figure drawing and encouraged painting of narrative subjects. Academy-trained artists such as Thomas Hovenden, William Henry Lippincott, and Anna Elizabeth Klumpke continued that academic figural tradition to the end of the century. Their Gilded Age fantasies of costumed courtiers, colonial-revival interiors, and happy French peasants evoke a long-lost past.

*Telling Tales: Nineteenth-Century Narrative Painting from the Collection of the Pennsylvania Academy of the Fine Arts* is one of a series of exhibitions designed to feature the strengths of the museum's permanent collection. The Pennsylvania Academy is able to present this exhibition and catalogue through a Special Initiatives Grant from the National Endowment for the Arts, a federal agency. It is the second of three exhibitions from the permanent collection supported by this grant. The first, *Light, Air, and Color: American Impressionist Paintings from the Collection of the Pennsylvania Academy of the Fine Arts,* was presented in 1990; the third, planned for 1992, will feature nineteenth-century American portraiture. The educational programs accompanying each of these exhibitions are made possible by the generous funding of the William Penn Foundation of Philadelphia. *Telling Tales* highlights the important interaction between visual and language arts in our schools and reflects the Academy's ongoing commitment to education.

This project is the result of the concerted efforts of the entire Academy staff. Susan Danly, curator, and Inez Wolins, curator of education, worked together to present the exhibition and educational programs to a wide-ranging audience: families, teachers, school groups, college classes, and scholars. The catalogue was edited by Jacolyn A. Mott, editor in chief. Rick Echelmeyer photographed the paintings, and Judy Hayman Moore in the registrar's office organized them for the catalogue. The coordination of the catalogue, as well as the national tour of the exhibition, was arranged by the staff of the American Federation of Arts under the direction of Serena Rattazzi. As a result of their efforts, the exhibition will have an impact well beyond the city of Philadelphia.

Linda Bantel
*Edna S. Tuttleman Director of the Museum, Pennsylvania Academy of the Fine Arts*

# ACKNOWLEDGMENTS

The second in a series of three collaborations with the Pennsylvania Academy of the Fine Arts, *Telling Tales* is a captivating exhibition presenting pictures that do indeed "tell tales" – tales of history, tales of literature, and tales of everyday life. Narrative paintings such as these represent an important tradition in American art that has yet to receive the attention it deserves. Few collections in this country so comprehensively document this tradition as that of the Pennsylvania Academy of the Fine Arts. The AFA is very pleased to be working with the Academy to circulate this exhibition, and we wish to extend our deep appreciation to Linda Bantel, director of the Academy's museum, for her cooperation in this collaborative endeavor. We also want to thank curator Susan Danly for her fresh evaluation. At the AFA we want to acknowledge the work of Robert Workman, administrator for exhibitions; Michaelyn Mitchell, head of publications; Carol Farra, registrar; and Julie Min, exhibition scheduler. Last but not least, our gratitude goes once more to the Lila Wallace – Reader's Digest Fund for their support through the AFA's ART ACCESS program.

Serena Rattazzi
*Director*
*The American Federation of Arts*

The most recent publication on the subject of American narrative painting, *Grand Illusions: History Painting in America* by William H. Gerdts and Mark Thistlethwaite, grew out of plans for an exhibition on this long-neglected topic. That exhibition never came to fruition, partly because of the difficulty in bringing together many large and important paintings from all over the country. But such an exhibition was relatively easy to do under the aegis of the Pennsylvania Academy. Because the Academy began collecting narrative pictures soon after its inception in 1805 and continued to do so throughout the nineteenth century, it has amassed one of the most comprehensive collections of historical, literary, and genre painting to be found in any museum of American art.

While the pictures for this exhibition were all in hand at the Academy, the research that has gone into this catalogue has involved the efforts of many people at other institutions. I would like to thank especially the Huntington Library in San Marino, California, which provided me with a Virginia Steele Scott Research Fellowship and gave me access to a marvelous library of rare books and a collection of British and American art rich in narrative subjects. Shelley Bennett, curator at the Huntington, shared her knowledge of the British narrative tradition, as did fellow Huntington researchers Malcolm Baker of the Victoria and Albert Museum and Stephen Lloyd of Oxford University. Professor Elizabeth Johns at the University of Pennsylvania has also taken much interest in this topic, and her ideas about the role of narrative painting in American culture have been most helpful. My own research on specific painters and collectors was aided by Virginia Cooper, a descendant of the Thomas Shields Clarke family; by Susan Nutty at the University of Delaware, who is working on Philadelphia art collections in the nineteenth century; and by Julie Nicoletta at Yale University, my research assistant on this project.

Several Academy staff members and friends provided information and read drafts of the catalogue manuscript: Judith Stein and Jeanette Toohey, curators; Cheryl Leibold, archivist; Tamsin Wolff, education specialist; Anne Monahan, curatorial assistant; and James F. O'Gorman, Grace Slack McNeil Professor of the History of American Art at Wellesley College. Mark Bockrath, Nancy Pollack, and Robin Beckett in the Conservation Department gave their careful attention to many paintings and period frames so that these works would look their best. Serena Orteca produced the labels, and the museum preparators under the direction of Tim Gilfillan ably installed the exhibition. Most important, I must acknowledge the contribution of my daughter, Abigail Newton Walther, to whom I owe my longstanding interest in "telling tales." It was with her that I first shared the pleasures of narrative art in a child's picture book.

Susan Danly
*Curator, Pennsylvania Academy of the Fine Arts*

# A Short History of Narrative Painting
## at the Pennsylvania Academy of the Fine Arts

*It is with great pleasure that we have noticed that the present exhibition of the Academy is exciting great attention, and that it bids fair to attract an unusual amount of visitors.... Still more gratified should we be if the public would only realize that such exhibitions are in reality something more than places of mere amusements. The contemplation of beautiful works of art, in a thoroughly cultivated mind, produces the same result as the perusal of the most refined classical writers – we might say, of the best poets. (Philadelphia* Evening Bulletin, *May 13, 1856, p. 1)*

Many of the works of art shown in the 1856 annual exhibition of the Pennsylvania Academy of the Fine Arts were narrative paintings – pictures that tell tales of history, literature, and everyday life.[1] Clearly viewed as a popular form of entertainment and education in nineteenth-century America, the stories depicted in these paintings are often unfamiliar or only vaguely understood by the present museum visitor. The stories are important, however, not only because they represent a long-neglected aesthetic tradition but also because they reveal much about the cultural tastes and aspirations of the society that produced them. This catalogue and the exhibition it accompanies thus focus on the dual nature of "telling tales." Each painting not only illustrates a specific story but also illuminates, sometimes unintentionally, broader issues relevant to the lives of nineteenth-century Americans. Important national concerns such as western expansion, cultural identity, social class, literacy, and urbanization were often imbedded in scenes of classical Greece, storm-tossed ships, and European peasants.

While American narrative painting has deep roots in European art in terms of both content and form, the interplay between European influence and local interest provides the key to the interpretation and analysis of its imagery. Narrative painting provided moral and religious lessons, illustrated the social and political concerns of the day, and served as a model from which America's young artists could learn to paint. During the course of the nineteenth century, however, there was a gradual shift away from traditional themes based on European history and literature, toward American genre scenes (depictions of everyday life). Such scenes were more easily understood by the American public, and they reflected the democratization of American culture. While this phenomenon is not unique to American art, it takes on particular relevance in this country because of the political principles on which the nation was founded.

The Pennsylvania Academy of the Fine Arts accorded special emphasis to narrative painting throughout the nineteenth century. Established in 1805 to educate the American public and artists alike, the Pennsylvania Academy exhibited and collected narrative paintings as teaching tools.[2] Its exhibitions (fig. 1) and method of instruction were modeled after those of the Royal Academy in London, founded in 1768. Foremost among their shared academic ideals was the belief that the highest form of art was based on the human figure and illustrated edifying scenes drawn from history or literature. According to the principles laid down by the first president of the Royal Academy, Sir Joshua Reynolds,[3] these so-called history paintings

were more important than portrait, landscape, or still-life subjects because they required the greatest amount of academic training. A history painting required a thorough knowledge of anatomy and the ability to convey emotions through gesture and facial expression in addition to the proper selection of a narrative subject. But such erudite subjects were also the most difficult to understand. Aristocratic British audiences, who were well educated and well traveled, usually recognized the arcane classical myths, biblical passages, and references to traditional Renaissance art in narrative paintings. The American public often did not.

The Pennsylvania Academy took it upon itself to promote such difficult subjects by educating its audience. Narrative paintings with complex themes or obscure references were described at length in exhibition catalogues that cited the appropriate literary texts. Among the most important narrative works of art acquired by the Academy in the nineteenth century were two monumental paintings by the expatriate Pennsylvania artist Benjamin West (1738-1820). West, the second president of the Royal Academy, began his artistic career in America as a self-taught, provincial portrait painter. After traveling throughout Italy and receiving an academic education there and in England, he became one of Europe's leading history painters. West's dramatic ascent from an obscure colonial limner to an acknowledged luminary in European art circles served as a model for younger American artists. The Pennsylvania Academy was so eager to obtain an example of West's much acclaimed work that it mortgaged its own building in 1836 to acquire *Death on the Pale Horse* (fig. 2).

This complex religious work was the last and most monumental version of a biblical subject that West painted three times between 1783 and 1817. The earlier versions were begun as studies for a painting commissioned by King George III for his private chapel at Windsor Castle, a project that was never completed. The final version, however, was intended for public exhibition in London. When it was first shown there in 1817, the painting was accompanied by a pamphlet that quoted appropriate passages from the Book of Revelation. This last of the New Testament books is filled with especially vivid imagery that lends itself to visual representation. West's painting centers around the horrifying images described in chapter 6, verse 7: "Behold a pale horse, and its rider's name was Death, and Hades followed him; and they were given power over a fourth of the earth, to kill with sword and with famine and with pestilence and by wild beasts of the earth." The large scale of the painting, coupled with numerous scenes of physical suffering and emotional distress, powerfully conveys a terror-filled vision of the Apocalypse. West's choice of such an emotionally charged scene was typical of the romantic period, when both painters and writers focused on subjects that illustrated the sublime: the overwhelming power of religious beliefs, the supernatural world of dreams, or the cataclysmic forces of nature.

The various possibilities for interpretation of West's painting were recognized immediately. Soon after it went on public exhibition in London, the publisher and writer

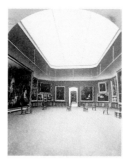

William Carey issued a 172-page text that described the painting, provided a stylistic analysis, identified the actions of the various groups of figures, and suggested ways to interpret the painting.[5] For Carey it was an ambitious attempt to illustrate a biblical passage filled with potent imagery; and it alluded to historical themes, as well. Carey cited an eighteenth-century theory that this scene was a prophetic reference to a later period of Roman history marked by wars between the Romans and the Jews, and he further suggested that the battle in the background depicted a scene from the Crusades.

Carey presented a copy of his book to the Pennsylvania Academy in 1818; therefore it seems likely that the directors of the institution were well aware of the critical acclaim surrounding this work when it was first offered to them for sale after the artist's death in 1820. At that time, the painting hung opposite another monumental biblical scene, *Christ Rejected* (fig. 3), in the Great Room of West's public gallery in London. Today these two works face each other once again in the Grand Stairhall of the Pennsylvania Academy, where their overwhelming scale and theatrical compositions still elicit feelings of the "terrible sublime," as West intended. Each painting, over sixteen feet high and twenty feet long, is filled with numerous figures, whose animated gestures convey the heightened emotional state represented by its narrative subject.

*Christ Rejected* is based on a combination of all four Gospel texts that tell of the moment when the Jewish priests and elders demanded Christ's death from the Roman authorities. The High Priest, Caiaphas, stands in the center of the composition, with Pontius Pilate just to the left, gesturing toward the figure of Christ.[6] Christ's disciples, Joseph of Arimathea, James the Less, and Peter, along with the swooning figure of the Virgin Mary supported by John the Baptist, are arranged at the lower right of the composition, in front of the jeering crowd. Like another of West's popular narrative works painted for a Philadelphia audience, *Christ Healing the Sick*, 1811 (Pennsylvania Hospital, Philadelphia), this work was intended for viewing by the general public rather than a private patron.

The monumental presence of West's large paintings is related to other forms of popular entertainment – the dioramas and panoramas of the nineteenth century and their modern equivalent, the motion picture. Like these pictorial shows, which traveled from one city to the next and were shown to packed houses, West's paintings were exhibited publicly to a wide audience. A copy of *Christ Rejected* was shown in the United States as early as 1821; and when the original work arrived in 1829, it attracted considerable crowds in New York and Philadelphia. The painting was displayed in several of the annual exhibitions at the Pennsylvania Academy, including the 1843 exhibition, which featured a special section devoted to religious art. In 1862 an exhibition pamphlet declared, "The artist has succeeded in the one most essential quality of a historical painting – he has told the story clearly." Despite this claim, the pamphlet went on to explain in detail the actions and emotions of all of the principal figures. It concluded by stressing West's importance as an artist, particularly in his natal city: "Benjamin

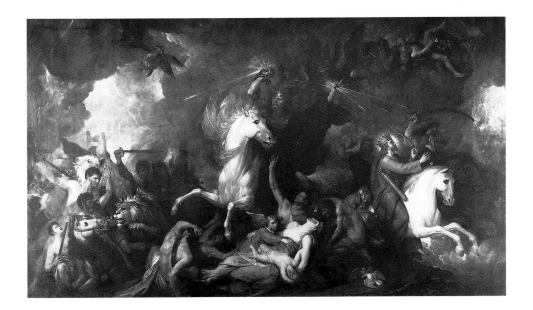

West is eminently worthy of being regarded with affectionate interest by all, but more especially by Philadelphians who have pride in their native city and the distinguished men who have reflected honor upon it by their worth or genius" *(Description of West's Great Picture, Christ Rejected*, 1862, Archives of Pennsylvania Academy).

Another important American artist of this period, who studied with Benjamin West in London, was Washington Allston (1779-1843). The Pennsylvania Academy's 1816 purchase of Allston's monumental religious painting *The Dead Man Restored to Life by Touching the Bones of the Prophet Elisha* (fig. 4) typifies the institution's early support of narrative art in America.[7] A Boston-born artist, Allston had hoped to emulate West's career as a history painter in England but was disappointed by his lack of British patronage. He was pleased when this work found an American patron, James MacMurtrie of Philadelphia. With the help of the painter Thomas Sully (1783-1872), MacMurtrie persuaded the directors of the Academy to purchase the painting for the highest price ever paid at the time for work by a native-born artist. After mortgaging the building to purchase the painting, the Academy proudly featured it in the 1816 annual exhibition, along with another large narrative painting, *The Murder of Rutland by Lord Clifford* by Charles R. Leslie (cat. no. 10). Allston's painting was shown periodically in other annual exhibitions, usually accompanied by a written text in the catalogue to explain the subject.

The biblical text for *The Dead Man Restored to Life* is derived from the Old Testament: "And the bands of the Moabites invaded the lands at the coming of the year. And it came to pass as they were burying a man, that behold, they spied a band of men and they cast

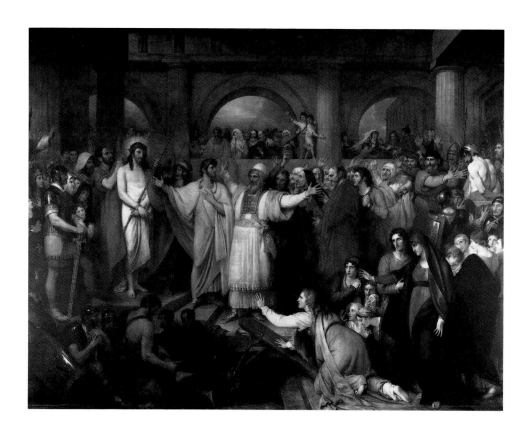

the man into the Sepulchre of Elisha; and when the man was let down, and touched the bones of Elisha, he revived" (2 Kings 13:20-21). Allston chose to illustrate the miraculous moment of revival or resurrection of the dead man in a monumental painting. The dramatic nature of the event is conveyed by the gestures and facial expressions of the figures and in the chiaroscuro, or highlighting, of the scene. Despite the theatricality of the poses and the lugubrious mood created by the somber coloring and dark shadows, the story itself is not readily understood without a written text. Allston himself composed one such text that described the cavelike setting and identified the emotional response of each of the participants.[8] Filled with phrases such as "astonishment and fear," "unqualified, immoveable terror," and "violent and terrified action," Allston's text underscored the romantic appeal of this picture as an expression of intense emotions in the face of sublime or supernatural power.

The directors of the Pennsylvania Academy were eager to include such grandiose narrative works in their fledgling collection of American art for several reasons. They believed that such paintings, filled with religious ideals, served to educate and elevate the intellect of the general public. Furthermore, Allston's knowledgeable borrowings from classical sculpture and Old Master paintings provided a model for artistic education. Younger American artists, who

might not have had the advantage of traveling or working in Europe, were able to learn about the traditional forms of Renaissance and baroque art by studying Allston's work. For example in this work, Allston adapted a famous pose of a figure from the Parthenon frieze which was also used by Raphael for the figure of the dead man. Finally, the emotional content of romantic art could be experienced by a broad spectrum of the public, who responded directly to the dramatic expressions of the figures even if they could not comprehend the details of the story.

The annual exhibitions of the Pennsylvania Academy, begun in 1807, provided one of the principal venues for the display of both European and American narrative paintings throughout the nineteenth century. During the early years, the number of European works almost always outnumbered those produced by American artists. Although many of these paintings were copies of original works still in European collections, they provided an opportunity for American audiences to compare the style of Old Master paintings with that of works by contemporary European and American artists. Between 1810 and 1830, narrative paintings by or after such well-known Renaissance and baroque painters as Tintoretto, Rubens, Brueghel, Teniers, and Murillo hung beside similar subjects by West, Allston, Leslie, and Sully.

Throughout his career, Thomas Sully made numerous copies of Old Master and contemporary European narrative paintings as a means of study. In 1812, he copied Peter Paul Rubens's seventeenth-century religious painting *The Tribute Money* and the following year, a work by the English artist John Opie, *Gil Blas Securing the Cook in the Robbers' Cave* (cat. no. 9), a subject based on a French novel. Both of Sully's copies and Opie's painting were deemed important enough during the nineteenth century to be acquired for the permanent collection of the Pennsylvania Academy. While the Academy's annual exhibitions also included landscapes and portraiture, narrative paintings often received special attention in the local press. A reviewer of the 1812 exhibition, for example, singled out several narrative paintings by Sully and especially commended his choice of historical subjects drawn from American history: "It is extremely gratifying to the lovers of the fine arts in this country, to see a taste and disposition to encourage historical painting and engraving, by introducing among us a taste for subjects from our own history. It is certainly the most proper method to establish schools of art in America" (*Portfolio Magazine* 8, no. 1, [July 1812], pp. 22-23).

Among the first works of art acquired by the Academy in the nineteenth century was Sully's portrait of the Shakespearean actor George Frederick Cooke as Richard III, painted in 1811-12 (fig. 5). In the early nineteenth century, after the ban prohibiting theatrical performances during the Revolutionary War was lifted, Philadelphia saw the rapid growth of numerous theaters, many of which specialized in productions of Shakespeare. George Frederick Cooke, an English actor who captivated local audiences with his portrayal of Richard III, was mobbed by the public when he left the theater.[9] Sully's dramatic portrait of Cooke not only captured the features of one of the first stars of the American stage but also represented a

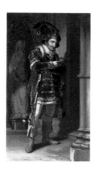

new type of popular narrative art based on the European drama. Another American, Charles R. Leslie, who had close ties with both Sully in Philadelphia and West in London, went on to specialize in Shakespearean subjects (see cat. nos. 10 and 11).

In addition to works by Sully, Leslie, and Allston that showed the influence of contemporary British art, there were a number of works exhibited at the Pennsylvania Academy that demonstrated a deep-seated taste for French neoclassicism in Philadelphia. Between 1810 and 1820, paintings by the French neoclassical artist Denis A. Volozon (see cat. no. 2) were frequently exhibited, as were portrait busts by France's leading neoclassical sculptor, Jean-Antoine Houdon, and drawings by some of America's most important neoclassical architects, such as Benjamin Henry Latrobe (1764-1820), Robert Mills (1781-1855), and William Strickland (1788-1854).

One of the most intriguing works of neoclassical art produced by an American artist during the early part of the nineteenth century is John Vanderlyn's *Ariadne Asleep on the Island of Naxos* of 1810-14 (fig. 6). This painting, now in the collection of the Pennsylvania Academy, depicts Ariadne, a Greek maiden who defied the wishes of her father, Minos, and saved the Athenian hero Theseus from the labyrinth of the monstrous Minotaur. Theseus then seduced and stranded the young woman, asleep and unknowingly with child on the island of Naxos. A popular myth that often appears in Renaissance and baroque art, it was recounted by a number of classical authors including Ovid, Plutarch, Philostrates, and Catullus. Vanderlyn, alluding to the romantic irony depicted in his version of the story, said that he deliberately chose to show the nude Ariadne "as yet unconscious of her misfortune, asleep amidst the shade and deep foliage of that beautiful Island, and the bark which is to bear Theseus from her…in the distance."[10]

This ancient myth about sensual abandonment in nature provided Vanderlyn with an explicitly sexual image that he exploited to the fullest. As an American artist working in Paris, he was acutely aware of the differences in taste between French and American audiences. While the French were used to such scenes of nudity in neoclassical narrative paintings, Americans were far less accustomed to such overtly sensual imagery. Painted for the annual Paris Salon of 1812,[11] Vanderlyn's painting had little popular appeal in the United States. When it was exhibited in New York between 1819 and 1829, William Dunlap (1766-1839), the first historian of American art, reported that the English engraver and drawing teacher John Rubens Smith (1775-1849) refused to bring his American pupils to see Vanderlyn's "indecent pictures."[12] Even after the painting entered the collection of the Pennsylvania Academy in 1878, it continued to upset the general public. As late as 1891, the Academy received an official complaint from female visitors about Ariadne's "flagrant indelicacy."[13]

A recent scholar has noted, however, that there is an important parallel between the classical myth of Ariadne and the indigenous legend of Pocahontas, first popularized in the early nineteenth century.[14] In the American version of this story, Pocahontas, like Ariadne,

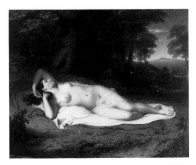

gives up her native culture in order to save a foreign soldier, Captain John Smith, who later abandons her. Although Vanderlyn's depiction of the nude Ariadne was deemed too risqué for the American public in the nineteenth century, the story of seduction and abandonment was not. Narrative painters who rose to prominence in the 1830s and 1840s soon learned to combine more easily understood scenes based on American life with the traditional forms of European history painting.

The genre paintings of William Sidney Mount (1807-1868) best represent the new direction that narrative painting would take during the mid-nineteenth century. Like many narrative painters of the period, Mount turned his back on European history and literature to draw his genre subjects from everyday life. He did not abandon the form and meaning of European art altogether, however, and, in his masterpiece *The Painter's Triumph* of 1838 (fig. 7), he gives new expression to the fusion of Old World and New World culture. Mount's painting presents a moralizing tale in which an urbane, educated artist is shown elevating the cultural tastes of an ordinary middle-class American farmer.[15]

To convey this message about the educational value of narrative art was one of the primary goals of the Pennsylvania Academy, which first exhibited this work in 1847. Through its annual exhibitions and support for the traditional academic training of artists, the Academy hoped to increase public awareness about the aesthetic and moral value of art. Mount conveys this very sentiment in the lively facial expressions of the artist and the farmer, who examine the painting before them with evident pleasure. The dramatic gesture of the artist leads the viewer's eye from the easel to a drawing of a Greek sculpture tacked to the studio wall behind him.

Known to be an ancient Roman copy of the Greek work, the *Apollo Belvedere* was one of the most famous fragments of classical sculpture to be rediscovered during the Renaissance, and it quickly became a model for artists of the sixteenth and seventeenth centuries. In the eighteenth century, it was often cast in plaster and used for academic drawing classes. Benjamin West used the pose of the *Apollo Belvedere* for the figures of William Penn and one of the Indian chiefs in *Penn's Treaty with the Indians* of 1772 (fig. 8; see also cat. no. 16), one of the first truly American history paintings. Among a group of casts commissioned by the Pennsylvania Academy from the Musée Napoleon in France in 1806, a copy of the *Apollo Belvedere* was one of the first art objects to enter the Academy's collection. Casts of this and other works of classical antiquity were exhibited for both the general public to see and students to copy. By the 1830s any illustration of this famous sculpture would have been easily recognized by an American audience.

The relatively simple narrative in Mount's painting was further embellished by a short story that accompanied a reproductive print of this painting in a popular Christmas publication called *The Gift* in 1839.[16] The short story inspired by the painting is set on the banks of the Susquehanna River in rural Pennsylvania. It tells how a portrait by a fictional New York artist, a Mr. Raphael Sketchly, changed the fortunes of a middle-class Philadelphia family that

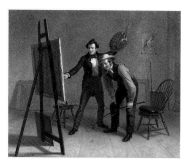

had lost much of its wealth and social status during the financial crisis of 1835. The family eventually regained its position through a series of comic mix-ups and a case of mistaken identity involving the portrait. The complexities of the written text, which weaves in issues of class consciousness and national identity, further enlivened and deepened the meaning of Mount's painting for contemporary audiences.

This was precisely the intention of Edward L. Carey (1805-1845), the Philadelphia publisher who commissioned the painting and had it reproduced in *The Gift*, one of his most popular publications.[17] Edward was the nephew of William Carey, the art critic and collector who had done much to promote the work of Benjamin West in Philadelphia. A knowledgeable collector of both European and American art, Edward was also the brother-in-law of the expatriate American painter Charles R. Leslie (see cat. nos. 10 and 11) and shared with him a taste for narrative subjects. The two had traveled throughout England in 1818 visiting art collections, and the young Carey was especially impressed with West's monumental painting *Death on the Pale Horse* (fig. 2).

When Carey began to form his own collection in the 1830s, he turned to American artists, particularly genre painters. He commissioned some of the earliest and most important works to be shown at the annual exhibitions of the Pennsylvania Academy. Among those paintings, many of which were also reproduced as prints in his gift books, were Henry Inman's *Mumble-the-Peg* (cat. no. 23), James G. Clonney's *Militia Training* (cat. no. 25), William Page's *The Young Merchants* (cat. no. 24), and George H. Comegys's *The Ghost Story* (cat. no. 22). Carey was also an important patron of the narrative painter Daniel Huntington, whose subjects were drawn from more traditional European literary and historical themes (see cat. no. 8).

Edward Carey died in 1845, but his art collection remained intact, as a bequest to his sister Maria and brother Henry (see fig. 9). Even a decade later, Carey's importance as a collector was acknowledged by one of America's leading art journals: "The influence of Mr. Carey upon the world of Art in Philadelphia was great; his good feeling and liberality were conspicuous, and he left behind him a reputation which is warmly cherished by his friends, and which must encourage all who follow in the same path" (*Crayon*, Feb. 7, 1855, p. 92). Given to the Pennsylvania Academy in 1879, the Carey collection was one of the first coherent groups of narrative paintings to enter a public museum in America.

The interest in narrative painting established by Carey continued to dominate taste in Philadelphia throughout the second half of the nineteenth century. Among the most important collections amassed during this period was that of Joseph Harrison, Jr. (1810-1874), a wealthy industrialist, who was elected to the board of directors of the Pennsylvania Academy in 1854.[18] In the 1850s Harrison built a large town house with its own private art gallery (fig. 10) on Philadelphia's fashionable Rittenhouse Square. The gallery had space for his extensive collection, which included *Penn's Treaty with the Indians, Christ Rejected,* and *Ariadne Asleep*

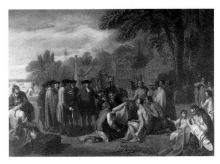

*on the Island of Naxos*. Harrison was an ardent supporter of both Christian Schussele (see cat. no. 7) and Peter Rothermel (see cat. no. 14), the leading history painters of his day. Harrison's collection also included works by other narrative artists, such as Edward Harrison May, Jr., Thomas Buchanan Read, Emanuel Leutze, William Page, and James Hamilton (see cat. nos. 32, 3, 13, 24, and 19, respectively), who frequently participated in the Pennsylvania Academy's annual exhibitions.[19]

In 1868 the European-trained Schussele became the first artist to direct a planned curriculum of classes at the Pennsylvania Academy. He formalized many academic practices, such as drawing from casts and drawing from live models, which had been taught on an informal basis at the Academy prior to his day. Because of the emphasis placed on anatomy and academic subjects at the Academy after the Civil War, many of the artists who studied there, such as William B. T. Trego (see cat. no. 27), William Henry Lippincott (see cat. no. 36), and Philip B. Hahs (see cat. no. 35), were especially skilled at rendering the human figure and sought out narrative subjects that utilized their abilities in this field.

The Pennsylvania Academy's purchases of art and the prizes awarded at its annual exhibitions after 1876 seemed to favor narrative subjects. Joseph E. Temple (1811-1886), a successful Philadelphia dry-goods merchant who endowed an Academy purchase fund in 1880, was especially fond of storytelling paintings. Among the works acquired with his money were genre scenes by Burr Nicholls (see cat. no. 39), Henry Mosler, (see cat. no. 38), and Robert Koehler (see cat. no. 40). Temple, a typical art connoisseur of the Gilded Age, was wealthy and well traveled. Between 1867 and 1878 he toured the United States, Europe, and the Far East. His interest in simple rural subjects was a reflection of both his personal love of country life and broader social concerns about the decline of rural areas in an age of industrialism and urbanization. The quick demise, after only one year, of a competition for history painting funded by Joseph Temple suggests that by the late nineteenth century the taste for narrative subjects in American art had moved away from bombastic historical themes toward quieter domestic scenes.[20]

By the 1890s, the Pennsylvania Academy, one of the last bastions of the academic figurative tradition, began to feel the impact of impressionism – advertising it as "The Dawn of a New American Art." Arising from a similar concern for ruralism and an interest in French peasant life, impressionism differed from academic genre painting in that it emphasized landscape over narrative themes and spontaneous brushwork over carefully rendered preparatory drawing. When figures do occur in impressionist paintings, they are usually small in scale and rendered with the characteristically sketchy brush strokes that do not accommodate much in the way of narrative detail. The sweet sentiment and quaint costumes in genre scenes by Mosler, Koehler, and Lippincott gave way by the turn of the century to a greater interest in the effects of light, air, and color in impressionist landscapes by Academy teachers and students.[21]

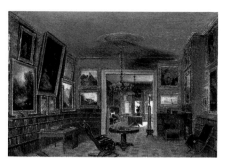

While the Academy continued to sustain an interest in the human figure, for the most part it was limited to portraiture.

Narrative subjects, especially those based on historical, religious, or literary themes, seemed old-fashioned in an age when contemporaneity and spontaneity became highly prized aesthetic qualities. When modernism and, later, abstraction emerged as powerful forces in American art during the teens, the narrative tradition was suppressed. It never disappeared entirely, however. With the advent of social realism and surrealism in the 1930s, the associative power of painting to represent or allude to specific images and stories once again became important. Today, as figuration has reappeared in contemporary American art, the narrative mode has once again become a potent means of artistic expression.[22]

Recently, art historians have begun to reexamine the lives and works of many of the earlier narrative painters who had fallen into obscurity. They have also begun to explain how painters in the past went about telling tales and how their approach to pictorial narration changed from one period to the next.[23] According to Svetlana Alpers, an art historian who has incorporated ideas from the field of literary criticism into her work, two elements are necessary for a painting to tell a story: narration and imitation must be understood by the viewer.[24] Narration involves the artist's ability to utilize the poses, actions, and emotional expressions of the figures in the painting to tell a story; imitation demands skill in rendering convincingly the costumes and setting of the subject. In the Renaissance, artists such as Raphael and Albrecht Dürer usually found a balance between narration and imitation in their paintings. But during the seventeenth century, these two elements began to pull away from one another. In some paintings, such as those by Nicholas Poussin, the storytelling aspects dominate; in others, notably works by Caravaggio or Jan Vermeer, imitation of the real world is the stronger element.

With the rise of romanticism at the beginning of the nineteenth century, the traditional relationship between narration and imitation broke down completely. Narration took the form of scenes suspended in time, anecdotes, often independent of any specific literary text; imitation turned into pure artifice. Precise interpretation of such works was left to the critic or to the public's imagination. Their subjective responses, based on emotions or personal experience, determined the meaning of a narrative work. Furthermore, as genre painting began to supersede history painting as a more popular form of narrative subject, it became increasingly difficult to separate them as distinct categories of art. In the United States, where artists were less tied to traditional artistic norms, because of both their lack of education and their search for a separate artistic identity, narrative painting came to be seen as all-encompassing, capable of absorbing European influences but expressing American themes.

The paintings exhibited at the Pennsylvania Academy in the early nineteenth century reflect these critical changes that occurred in European and American narrative art. Thomas Sully's image of the actor George Frederick Cooke is both a depiction of a famous

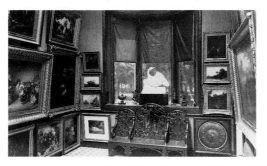

Shakespearean drama and a portrait of a local Philadelphia celebrity. William Sidney Mount's genre scene *The Painter's Triumph* explores the impact of European classical culture on everyday life in America.

The works in the catalogue section of this book are organized thematically to reflect shifts in taste, style, and subject matter that occurred in narrative art over the course of the nineteenth century. While taking into account European literary sources and the role played by European art academies in shaping American art, the discussions of individual works seek to place them in the context of American history and art patronage. The paintings in "European Themes" (cat. nos. 1-13) are based on the classical tradition, on more modern European literature, and on the Bible. This kind of narrative painting was most popular in the first decades of the nineteenth century, but during the 1830s the taste for narrative paintings that were so dependent on European subjects and styles began to wane.

The literary paintings of West and Allston, once perceived as the epitome of academic learnedness and skill, lost favor in the face of American subjects drawn from historical events and everyday life. Allston's *The Dead Man Restored to Life by Touching the Bones of the Prophet Elisha* was lambasted in the pages of a Philadelphia literary magazine in 1839 for being too exaggerated in its emotionalism. The writer suggested that "the delineator of such a monstrosity aught to be rolled up in his canvas, and both of them burnt on the altar of beauty" (*Burton's Gentleman's Magazine* 5, [July-Dec., 1839], p. 78). One of the chief criticisms of Allston's painting was its failure to suggest future action; that is, the artist did not leave much room for the viewer's imagination to continue the story.

Recognition of this new demand for inventiveness and increased interaction between the viewer and the painting is critical for an understanding of nineteenth-century narrative art. When the subject of a narrative painting no longer relates to the lives of its viewers, it falls out of fashion. As Americans became increasingly comfortable with the events and accomplishments of their own lives, they felt less dependent on European culture for validation. The works of art in "American Themes" (cat. nos. 14-27) reflect this shift toward American imagery and a more open-ended interpretation of narrative subjects. In the two decades preceding the Civil War, narrative painting in the United States turned inward, looking to subjects that reflected a national identity. The stories attached to the paintings by Mount and others in the pages of *The Gift* give some indication of this new direction (see cat. nos. 22-25).

After the Civil War, as a booming industrial economy increased wealth and time for leisure and travel, well-to-do American art patrons of the Gilded Age turned once again to European themes. "Gilded Age Fantasies" (cat. nos. 28-43) concentrates on works produced within an international art movement that found a large popular audience at the annual exhibitions of the Paris Salons, at international expositions in London, Berlin, and Chicago, and at

the annual exhibitions of the National Academy of Design in New York and the Pennsylvania Academy. Many of the narrative works exhibited in these places dealt with contemporary issues such as industrialization and changing gender roles but only in an oblique fashion. The domestic interiors of William Henry Lippincott (see cat. no. 36), for example, illustrate the specific concerns of the upper middle class.

More often than not, narrative painters of the late nineteenth century sought refuge in the imagination. They created fantasy worlds filled with elaborate costumes and elegant architectural settings. The charming scenes of medieval jesters by William Merritt Chase (see cat. no. 28) and Thomas Shields Clarke (see cat. no. 29) are artistic flights of fancy, created from the travel souvenirs that littered their studios. Escapist in nature, these fantasy pictures often have no particular narrative source; and the viewer is encouraged to invent a story based on his or her reaction to the image. The seductive quality of the richly painted surfaces in these fantasy pictures, especially evident in the works by Frank LeBrun Kirkpatrick (see cat. no. 31) and Thomas Hovenden (see cat. no. 30), is enhanced by the extreme degree of realism, or trompe l'oeil illusionism, employed by these artists. It further serves to transport the viewer back in time. While extremely realistic in style, the content of these paintings derived from a Renaissance or baroque world had little to do with modern life. Even when painting scenes of contemporary peasants, late-nineteenth-century artists often idealized their subjects, overlooking the aspects of poverty and hard physical labor that governed rural life. The quaintly garbed peasants in the popular works of Daniel Ridgway Knight (see cat. no. 41) are picturesque elements in a nostalgic scene of pastoral fantasy.

Because the Pennsylvania Academy exhibited, collected, and encouraged the painting of narrative art throughout the nineteenth century, its present collection constitutes an invaluable record of that period. The catalogue notes, poems, and short stories that helped explain these images to a popular audience broadened the appeal of such works from the realm of the knowledgeable art patron to that of the ordinary museum visitor. Philadelphia's leading art patrons, such as the Carey family, Joseph Harrison, and Joseph E. Temple, bequeathed their collections to the Academy because of their belief that narrative painting, more than any other form of art, would serve to elevate the moral and aesthetic perceptions of their fellow citizens. But as the century drew to a close, this paternalistic ideal fell short of its goal. The contradictions between city and country, between social classes, and between political and religious systems destroyed the rather naive belief that the visual arts could be morally uplifting. The role of storytelling previously held by narrative painting was subsumed into the field of magazine and book illustration. In the 1890s, the introduction of printing presses that could reproduce photographs and illustrations in color brought an end to nineteenth-century narrative painting. Storytelling pictures were now available in most American homes, not just on museum walls.

1. Among those narrative works now in the permanent collection of the Pennsylvania Academy are Benjamin West's *Death on the Pale Horse*, Washington Allston's *The Dead Man Restored to Life by Touching the Bones of the Prophet Elisha*, Thomas Sully's *George Frederick Cooke as Richard III*, John Lewis Krimmel's *Country Wedding, Bishop White Officiating*, and Charles R. Leslie's *The Murder of Rutland by Lord Clifford*.

2. For a discussion of the founding of the Pennsylvania Academy, see Frank H. Goodyear, Jr., "A History of the Pennsylvania Academy of the Fine Arts, 1805-1976," in *In This Academy* (Philadelphia: Pennsylvania Academy of the Fine Arts, 1976), pp. 12-47.

3. *Discourses on Art*, edited by Robert Wark (San Marino, Calif.: Huntington Library and Art Gallery, 1959). For further discussion of the development of academic teaching methods, see Nikolaus Pevsner, *Academies of Art, Past and Present* (New York, Da Capo Press, 1973), and Lois Marie Fink and Joshua C. Taylor, *Academy, The Academic Tradition in American Art*, exhib. cat. (Washington, D.C.: Smithsonian Institution Press, 1975).

4. Helmut von Erffa and Allan Staley, *The Paintings of Benjamin West* (New Haven: Yale University Press, 1986), no. 401, pp. 388-390.

5. William Carey, *Critical Description and Analytical Review of "Death on the Pale Horse," Painted by Benjamin West, P.R.A.* (London: published at 35, Mary-le-Bonne Street, Piccadilly, 1817).

6. Von Erffa and Staley, *Benjamin West*, no. 353, pp. 358-360.

7. For a detailed discussion of this painting, see Elizabeth Johns, "Washington Allston's *Dead Man Revived*," *Art Bulletin* 61 (March 1979), pp. 79-99, and William H. Gerdts, "The Paintings of Washington Allston," in *"A Man of Genius: The Art of Washington Allston*, exhib. cat. (Boston: Museum of Fine Arts, 1979), pp. 65-86.

8. *Catalogue of W. Allston's Pictures Exhibited at Merchant's Tailor's Hall, Broad Street, Bristol*, July 25, 1814.

9. For a discussion of the theatrical scene in early-nineteenth-century Philadelphia, see Reese D. James, *Old Drury of Philadelphia: A History of the Philadelphia Stage, 1800-1835* (Philadelphia: University of Pennsylvania Press, 1932), and Weldon B. Durham, *American Theatre Companies, 1749-1887* (Westport, Ct.: Greenwood Press, 1986).

10. Cited in William Townsend Oedel, "John Vanderlyn: French Neoclassicism and the Search for an American Art," Ph.D. diss., University of Delaware, 1981, pp. 365-509.

11. Lois Marie Fink, *American Art in the Nineteenth Century Paris Salons* (Washington, D.C.: Smithsonian Institution, 1990), pp. 25.

12. *History of the Rise and Progress of the Arts of Design in the United States* (New York: George P. Scott, 1834), p. 49.

13. Correspondence in Archives of Pennsylvania Academy.

14. David M. Lubin, *"Ariadne* and the Indians, Vanderlyn's Neoclassical Princess, Racial Seduction, and the Melodrama of Abandonment," *Smithsonian Studies in American Art* 3 (Spring 1989), pp. 3-21.

15. William T. Oedel and Todd S. Gernes, *"The Painter's Triumph*, William Sidney Mount and the Formation of a Middle-Class Art," *Winterthur Portfolio* 23 (Summer-Autumn 1988), pp. 111-127.

16. A. A. Harwood, "The Painter's Study," *The Gift* (Philadelphia: Carey and Hart, 1839), pp. 208-211. For a discussion of the importance of gift books, see Georgia Brady Baumgardner, "The Popularization of the Gentility, Illustrations in American Literacy Annuals," in *"The Documented Image*, Gabriel P. Weisberg and Laurinda S. Dixon, eds. (Syracuse: Syracuse University Press, 1987), pp. 13-26.

17. For a discussion of Carey as an art collector see Frank H. Goodyear, Jr., *The Beneficient Connoisseurs*, exhib. cat. (Philadelphia: Pennsylvania Academy of the Fine Arts, 1974), unpaginated.

18. Nicholas B. Wainwright, "Joseph Harrison, Jr., a forgotten art collector," *Antiques* 105 (Oct. 1972), pp. 660-668.

19. The Historical Society of Pennsylvania has two catalogues of the Harrison collection, *Catalogue of Pictures in the Gallery of Joseph Harrison, Jr.* (Philadelphia: Philadelphia Art Galleries, 1910) and *Paintings, Statuary, Etc., The Remainder of the Collection of the Late Joseph Harrison, Jr.* (Philadelphia: Philadelphia Art Galleries, 1912).

20. Mark Thistlethwaite, "Patronage Gone Awry: The 1883 Temple Competition of Historical Painting," *Pennsylvania Magazine of History and Biography* 112 (Oct. 1988), pp. 545-578.

21. For further discussion of the rise of impressionism at the Academy, see Susan Danly, *Light, Air, and Color: American Impressionist Paintings from the Collection of the Pennsylvania Academy of the Fine Arts*, exhib. cat. (Philadelphia: Pennsylvania Academy of the Fine Arts, 1990).

22. See, for example, Max Kozloff, "Through the Narrative Portal," *Artforum* 24 (April 1986), pp. 86-97.

23. For recent discussions of the narrative mode in British painting, see David Bindman, ed., *Essays on British Narrative Art* (San Marino, Calif.: Huntington Library, 1986) and Martin Meisel, *Realizations: Narrative, Pictorial, and Theatrical Arts in Nineteenth-Century England* (Princeton: Princeton University Press, 1983).

24. "Describe or Narrate? A Problem in Realistic Representation," *New Literary History* 8 (Autumn 1976), pp. 15-41.

ELIHU VEDDER
1836-1923

1.  *The Sphinx, Egypt,* 1890
    Oil on canvas
    20⅛ x 14¾ in. (51.1 x 37.5 cm)
    Bequest of Edgar P. Richardson, 1985.44

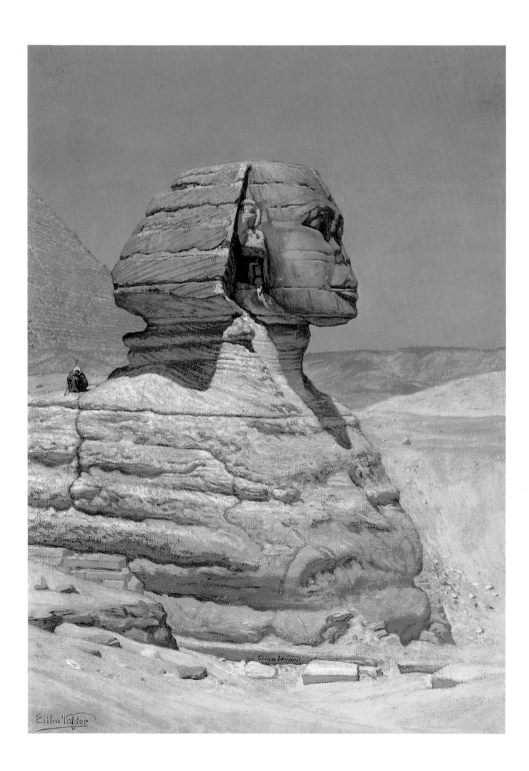

DENIS A. VOLOZON
active in America 1799-1819

2. *Homer Reciting His Poems in the City of Argos,* by 1811
Oil on canvas
32½ x 41¼ in. (82.6 x 104.8 cm)
Source unknown, 1834.1

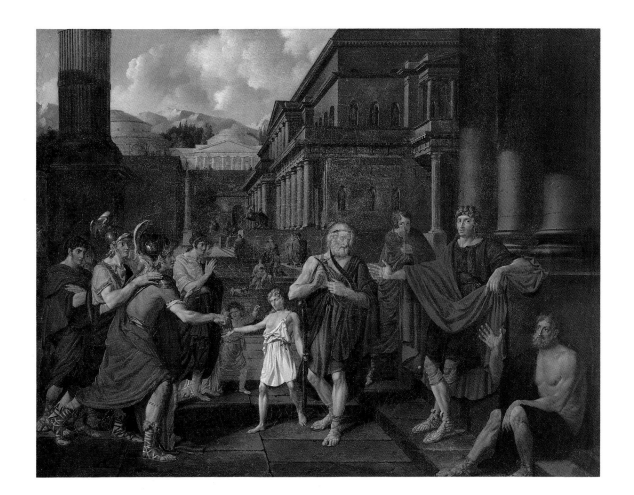

1. *The Sphinx, Egypt*, 1890
Oil on canvas
20⅛ x 14¾ in. (51.1 x 37.5 cm)
Bequest of Edgar P. Richardson, 1985.44

According to Greek mythology, the sphinx was a female monster who devoured all those who did not know that man was the answer to her riddle about the identity of a creature that walked on four legs in the morning, two at noon, and three in the evening. This kind of narrative, filled with mystery and threatened violence, fascinated Vedder and he exploited such subjects throughout his career as a romantic visionary. Although the sphinx was a theme that had preoccupied Vedder's imagination for almost thirty years, it was not until late in his career that the artist first saw the famous sculpture on a trip to Egypt in 1889.

Rather than illustrating the Greek myth in his paintings, Vedder chose to depict the older Egyptian sculpture, with the head of a man and body of a lion. Surrounded by the pyramids and drifting desert sands, this monumental sculpture stood as a kind of mute testament to the survival of ancient mythology. In an earlier painting *The Questioner of the Sphinx* of 1863 (Museum of Fine Arts, Boston), a kneeling figure listens at the lips of the half-buried sculpture, awaiting its response. But in the later version, completed after his visit to Giza, the tiny figure, huddling on the body of the sphinx, is seen from an even greater distance, further emphasizing the huge scale of the sculpture and the expanse of the desert beyond. Here man's existence seems even more fragile and ephemeral.

Writing home to his wife during the 1889 visit to Egypt, Vedder reported the sense of awe he experienced when he first came upon the Sphinx: "I was simply struck dumb. I never saw nor shall I ever see such a thing again....Words are vain but the grandness the strength the ineffable softness and richness of color tempt one to try to describe that which could only be represented in painting and even

then but faintly" (Letter of November 25, 1889, Archives of American Art). Although the Sphinx had just been excavated in 1886, Vedder hoped the ancient sculpture once again would be engulfed by the shifting sands.

REFERENCES:

Regina Soria, *Elihu Vedder: American Visionary Artist in Rome,* Rutherford, N.J.: Fairleigh Dickinson University Press, 1970, pp. 204-205, no. 453.

Carol Troyen, *The Boston Tradition: American Paintings from the Museum of Fine Arts, Boston,* exhib. cat., New York: American Federation of Arts, 1980, no. 49.

EUROPEAN THEMES

DENIS A. VOLOZON
active in America 1799-1819

2.  *Homer Reciting His Poems in the City of Argos*, by 1811
Oil on canvas
32½ x 41¼ in. (82.6 x 104.8 cm)
Source unknown, 1834.1

French-born Denis A. Volozon worked in Philadelphia between 1806 and 1819 and was a leading exponent of the neoclassical style. He frequently exhibited narrative paintings of classical subjects in the early annual exhibitions at the Pennsylvania Academy. In 1812, for example, Volozon showed *Ariadne Abandoned on the Rock of Naxos by Theseus* (location unknown), the same year John Vanderlyn exhibited a similar work at the Paris Salon (fig. 6). The poses and arrangement of figures in Volozon's painting reflect the influence of the art of Jacques-Louis David, France's leading neoclassical painter. Such paintings quickly became models of the latest neoclassical style, which the Academy's students could imitate.

In this work by Volozon, the aged, blind Homer stands in the center of the ancient city of Argos, playing a lyre and singing his epic verses. He is surrounded by an admiring audience, who listen entranced to his long narrative tale about the adventures of the Greeks during the Trojan War and its aftermath. Interest in Homer was especially keen at the time Volozon painted this work because of the controversy surrounding the identity of the poet. Some late-eighteenth-century scholars had begun to speculate that Homer had never lived and that the *Iliad* and the *Odyssey* were the result of a long oral tradition passed down by many generations of bards, or singing poets. In any case, over the centuries, Homeric poems had become the fundamental texts by which Greek language and mythology were taught. The directness and spontaneity of that oral tradition is aptly conveyed in the exaggerated facial expressions and gestures of the figures in the Volozon painting.

Despite the sense of historicity generated by this subject, its classical setting, and costumes, an examination of details reveals that Volozon depicted the ancient poet in a modern neoclassical style. Benjamin West (1738-1820) had used an almost identical setting for his painting *Mark Antony Showing the Robe and the Will of Julius Caesar to the People of Rome* (ca. 1775, location unknown). That work was offered to the Pennsylvania Academy for sale in 1809 and would have been known in Philadelphia through reproductive prints. Volozon's reinvention of classical architecture, with its combination of Greek columns and Roman domes, is typical of the Greek Revival style popular in Philadelphia during the early nineteenth century. John Dorsey's 1806 design for the original building of the Pennsylvania Academy, in which this work was exhibited, included similar neoclassical details.

REFERENCES:

Anna Wells Rutledge, *The Annual Exhibition Record of the Pennsylvania Academy of the Fine Arts, 1807-1870,* Madison, Ct.: Sound View Press, 1988, pp. 239-240.

David Sellin, "Denis A. Volozon, Philadelphia Neoclassicist," *Winterthur Portfolio* 4 (1968), pp. 119-128.

EUROPEAN THEMES

THOMAS BUCHANAN READ
1822-1872

3. *The Flight of the Arrow,* 1868
Oil on canvas
36 x 27¾ in. (91.4 x 70.5 cm)
Gift of the children of A. D. Jessup, 1881.3

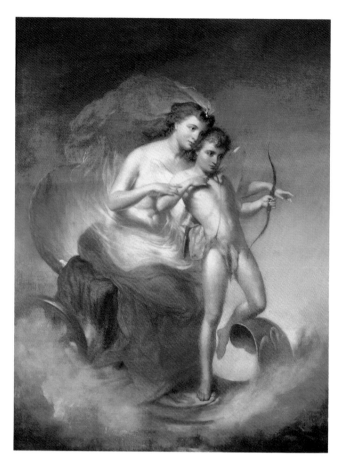

Born in Chester County, Pennsylvania, Thomas Buchanan Read spent most of his artistic career in Italy. There he made friends with a group of American expatriate sculptors who, like Read, specialized in narrative subjects that were drawn from classical literature and modeled after the art of the Italian Renaissance. Read exhibited several such narrative paintings, as well as portraits, at the Pennsylvania Academy between 1847 and 1866, including *Psyche Borne to the Island of Pleasure* (location unknown) and *Time Rescuing Proserpine from Plato's [sic] Region* (location unknown).

Read's lyrical approach to these subjects was more poetic than dramatic, as can be seen in this inventive pairing of Aphrodite and Eros. Aphrodite, the Greek goddess of love, is identified by her sensual nudity, the scallop shell, and the foaming sea that surrounds her. Her arms encircle the nude figure of her son, Eros, while she instructs him how to shoot the arrows of love. While Read's painting describes no particular event, his emphasis on soft flesh tones and diaphanous draperies certainly suggests the erotic character of many classical myths, even to an audience unfamiliar with specific narrative details.

REFERENCES:

Anna Wells Rutledge, *The Annual Exhibition Record of the Pennsylvania Academy of the Fine Arts, 1807-1870,* Madison, Ct.: Sound View Press, 1988, pp. 177-178.

Matthew Baigell, *Dictionary of American Art,* London: John Murray Ltd., 1979, p. 297.

EUROPEAN THEMES

4. *Bacchante*, 1872
Oil on canvas
24 x 19¹⁵/₁₆ in. (61 x 50.6 cm)
Gift of John Frederick Lewis, 1932.13.1

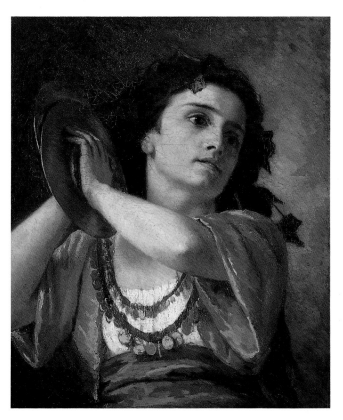

Mary Cassatt, like many American artists in
the nineteenth century, received a traditional
academic education. She enrolled at the Penn-
sylvania Academy in 1861 and took classes in
anatomy, drew from plaster casts of classical
sculpture, and copied paintings in the galler-
ies. Then she went abroad to study European
art firsthand. In Parma, she copied the works
of the Renaissance painter Correggio. This
canvas is based on those studies. It depicts a
bacchante, a female follower of the Roman
god of wine, Bacchus. Holding cymbals in her
hands and crowned with grape leaves, she is
meant to be seen reveling in the joys of drink.
More a figure study than a truly narrative
subject, it is only in the identification of these
attributes that the viewer can understand the
allusion to Greek mythology. In this respect,
the work is similar to other paintings of the
period, such as Thomas Buchanan Read's

*The Flight of the Arrow* (cat. no. 3), which
depend on symbols rather than action to
reveal the story behind the image.

That a taste for such erudite symbolism
was prevalent in Philadelphia is demon-
strated by the loan of this work to a special
exhibition at the Pennsylvania Academy in
1877. This show included John Vanderlyn's
*Ariadne Asleep on the Island of Naxos* (fig. 6)
along with works by European and American
artists from local private collections. Although
the show included landscapes, the majority of
the 372 paintings were of narrative subjects.

REFERENCES:

*Catalogue of an Exhibition by the Pennsylvania Academy
of the Fine Arts, of Choice Paintings from Private Galler-
ies of Philadelphia and Hans Makart's Great Picture of
"Venice Paying Homage to Caterina Cornaro,"* exhib.
cat., Philadelphia: Pennsylvania Academy of the Fine
Arts, 1877, no. 343.

Adelyn Dohme Breeskin, *Mary Cassatt, A Catalogue Rai-
sonné of the Oils, Pastels, Watercolors and Drawings,*
Washington, D.C.: Smithsonian Institution Press, 1970,
no. 15.

Suzanne G. Lindsay, *Mary Cassatt and Philadelphia,*
exhib. cat., Philadelphia: Philadelphia Museum of Art,
1985, pp. 18-19.

EUROPEAN THEMES

GEORGE WILLOUGHBY
MAYNARD
1843-1923

5.  *Sappho*, ca. 1888
    Oil on canvas
    24 1/16 x 20 1/8 in. (61.1 x 51.1 cm)
    Joseph E. Temple Fund, 1889.3

Best known as a mural painter of allegorical figurative subjects during the Renaissance revival of the late nineteenth century, George Willoughby Maynard also depicted classical themes on a smaller, more intimate scale. Maynard first studied figurative art in 1866 with the sculptor Henry Kirke Brown (1814-1886) and later enrolled at the National Academy of Design in New York. In 1869, traveling to Rome and Paris, he immersed himself in the traditions of classical art. He returned home in 1874 and began a career as a muralist, working on decorative programs for Trinity Church in Boston, the Library of Congress in Washington, D.C., and the 1893 World's Columbian Exposition in Chicago.

During this period, Maynard also showed several easel paintings at the annual exhibitions of the Pennsylvania Academy, including *Sappho,* which was shown in 1889. Sappho, the most celebrated female poet in ancient Greece, was an especially popular figure explored in both European and American artistic circles throughout the nineteenth century. In the absence of an extant biography, the details of her life were drawn largely from the fanciful account in Ovid's *Heroides*. Written in the first century A.D., this work is a series of imaginary love letters by mythic Greek figures. Sappho, the only human among them, was, according to Ovid, a famous poet who became enamored with a handsome young man, Phaon. When he spurned her love, she became melancholic and could no longer sing. Attempting to ease the anguish of this unrequited love, Sappho died by throwing herself from a cliff into the sea.

Maynard's image of Sappho, seated amidst the shadows with an unplayed lyre at her side, is typical of the many nineteenth-century interpretations of her story. It emphasizes the poet's despair and her inability to create without the inspiration of love. The pair of doves, billing and cooing at Sappho's feet, serves as a poignant reminder of her ear-lier successes. The brooding, introspective mood and melancholic pose of the figure in this work echo elements of famous Renaissance images, including Michelangelo's ceiling frescoes in the Sistine Chapel in Rome and Albrecht Dürer's print *Melancholia I.*

REFERENCES:

Natalie Spassky et al., *American Paintings in the Metropolitan Museum of Art: A Catalogue of Works by Artists Born between 1816 and 1845*, vol. 2. New York: Metropolitan Museum of Art, 1985, pp. 579-580.

Judith Ellen Stein, "The Iconography of Sappho, 1775-1875," Ph.D. diss., University of Pennsylvania, 1981.

Joan DeJean, *Fictions of Sappho, 1546-1937*, Chicago: University of Chicago Press, 1989.

EUROPEAN THEMES

6. *Noah and His Ark,* 1819
Oil on canvas
40¼ x 50¼ in. (102.2 x 127.6 cm)
Collections Fund, 1951.22

Charles Willson Peale was an artist who had an abiding interest in natural history. The biblical story of Noah and the Ark afforded him ample opportunity to exercise his skills as both a painter and a naturalist. Intended for a popular audience, this work was first exhibited in Peale's museum, located on the second floor of Independence Hall in Philadelphia. One of the earliest museums in America, Peale's gallery was an idiosyncratic combination: his portraits of notable Americans were displayed along with stuffed birds and animals and the bones of a mastodon.

*Noah and His Ark* is a copy of a work (location unkown) by the English artist Charles Catton, a noted animal painter in his day. In Peale's replica, he made only slight changes mostly for the sake of clarity. One alteration, however, was particularly significant given Peale's American audience. At the far left of the picture, he replaced the figure of an elk with an American buffalo, the animal that would become an icon for western expansion. In a letter written in 1819 while he was making this copy, Peale noted many of the salient points about the narrative elements of Catton's painting. He remarked on the wide variety of exotic species included in the painted image, which seems more like a zoo than the simple pairing of animals described in the biblical text (Gen. 7: 1-4). Peale also pointed out that Noah represents parental love, as he kneels in the foreground encircled by his family as well as the animals in this image. Himself the patriarch of a large family, Peale had retired by the time of this painting to his country estate, Belfield, just north of Philadelphia. There, like Noah, he became a tiller of the soil and took great delight in his vineyards.

REFERENCES:

Jane Dillenberger and Joshua C. Taylor, *The Hand and the Spirit: Religious Art in America, 1700-1900*, exhib. cat., Berkeley, Calif.: University Art Museum, 1972, p. 86.

May 1, 1819, letter from Charles Willson Peale to the owner of the Catton painting, Colonel Bomford in Washington, D.C., American Philosophical Society, Philadelphia.

Charles Dunlap, *History of the Rise and Progress of the Arts of Design in the United States*, vol. 2, New York: George P. Scott and Co., 1834, pp. 208-211.

EUROPEAN THEMES

GEORGE WILLOUGHBY
MAYNARD
1843-1923

5.  *Sappho*, ca. 1888
Oil on canvas
24 1/16 x 20 1/8 in. (61.1 x 51.1 cm)
Joseph E. Temple Fund, 1889.3

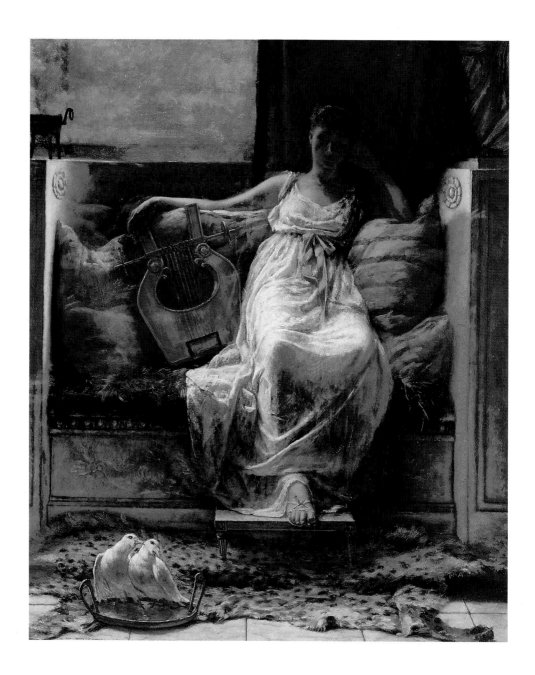

CHARLES WILLSON PEALE
1741-1827

6.  *Noah and His Ark*, 1819
    Oil on canvas
    40¼ x 50¼ in. (102.2 x 127.6 cm)
    Collections Fund, 1951.22

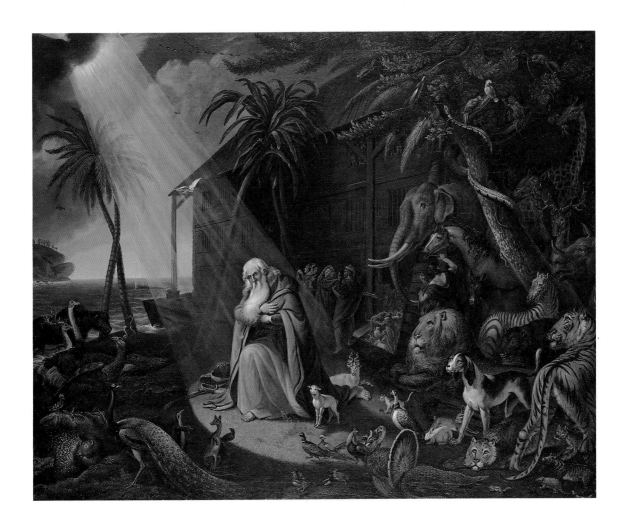

7. *King Solomon and the Iron Worker*, 1863
Oil on canvas
44 x 62¼ in. (111.8 x 158.1 cm)
Funds provided by an anonymous donor, 1990.15

The rabbinical legend of King Solomon tells the story of how a lowly laborer came to be honored at the dedication of an ancient Egyptian-style temple. Solomon had called all of his skilled craftsmen – architects, masons, and carpenters – to a feast and, when the uninvited ironworker presented himself, the king took great offense. The ironworker, proud of his skills, pointed out that without the tools that he made, the temple could not have been built. Conceding the ironworker's right to take part in the celebration, Solomon gave him a position of honor at the right of the throne. This is the scene depicted in Schussele's painting. The Egyptian revival frame, probably original to the painting, that surrounds this painting also relates Schussele's work both to the historical past and to an architectural style fashionable in mid-nineteenth-century America.

Schussele relied on the forms of traditional European history painting to recreate this rather unusual story at the request of a wealthy Philadelphia industrialist and art collector, Joseph Harrison, Jr. Apprenticed to a blacksmith at any early age, Harrison rose from the lowest ranks of labor to become a mechanical engineer and later the foreman and owner of a locomotive building company. In the 1840s he increased his wealth considerably while constructing railroad engines and cars in Russia. When Harrison returned to Philadelphia in 1852, much of his time was spent accumulating an art collection and in philanthropic endeavors, such as his support for the Pennsylvania Academy of the Fine Arts. For Harrison, this painting illustrated the dignity of manual labor and served as a symbol of his own life. He later incorporated its title for a volume of personal reminiscences that he published in 1869.

The story of the ironworker was first told to Harrison by a friend, Charles Godfrey Leland (1824-1903), a noted editor, writer, and abolitionist. Begun at the time of the Civil War, this painting would have had special meaning for those who saw it on display in Harrison's home, as part of the celebrations surrounding the 1864 Great Central Fair. The fair, organized by Harrison and others to raise funds for the Union cause, highlighted the arts and industry of the northern states. This work, celebrating the strength of industry, symbolized the Northern war effort.

REFERENCES:

Joseph E. Harrison, Jr., *The Iron Worker and King Solomon*, Philadelphia: J. B. Lippincott and Co., 1869.

Lois Dinnerstein, "The Iron Worker and King Solomon: Some Images of Labor in American Art," *Arts* 54 (Sept. 1979), pp. 112-117.

8.  *Mercy's Dream*, 1841
    Oil on canvas
    84½ x 66½ in. (214.6 x 168.9 cm)
    Bequest of Henry C. Carey (The Carey Collection),
    1879.8.10

In mid-nineteenth-century America, John Bunyan's moral tale of Christian perseverance, *The Pilgrim's Progress*, was second only to the Bible in popularity. First published in England between 1678 and 1684, it appeared in more than twenty editions in the United States in the 1840s. American audiences interpreted Bunyan's moral tale of Christian life as an expression of the Puritan ethic and saw parallels between the hazardous journey taken by the Christian soul on earth and those faced by settlers in the American wilderness. Daniel Huntington's painting *Mercy's Dream*, based on a visionary scene from part two of the book, was well known during the artist's lifetime; but its meaning is little understood by today's audiences. It illustrates the dream of a young girl, Mercy, in which an angel takes her to heaven and reveals the presence of God. This particular passage reaffirmed the divine nature of dreams, a favorite subject of the romantic era. It was a theme alluded to in other paintings of the period, such as Emanuel Leutze's *The Poet's Dream* (cat. no. 13), completed about this time and purchased by the same Philadelphia collector, Edward L. Carey.

In addition to two other painted versions of this scene by Huntington (1850, Corcoran Gallery of Art, Washington, D.C., and 1858, Metropolitan Museum of Art, New York), there were several prints of this popular image. Carey had one print engraved by John Cheney for the 1843 edition of *The Gift*, a popular illustrated Christmas book that he

published. In 1850 Andrew Ritchie's engraving of *Mercy's Dream* was distributed as a premium by the Art-Union of Philadelphia and the American Art-Union in New York, populist organizations that held lotteries to introduce notable works of American art to a wide audience. Huntington went on to paint another scene from Bunyan's work, *Christiana and Her Family Passing through the Valley of the Shadow of Death*, 1842-44, which was also acquired by Edward Carey and eventually bequeathed by his brother to the Pennsylvania Academy.

REFERENCES:

William H. Gerdts, "Daniel Huntington's *Mercy's Dream*, A Pilgrimage through Bunyanesque Imagery," *Winterthur Portfolio* 14 (Summer 1979), pp. 171-194.

Natalie Spassky et al., *American Paintings in the Metropolitan Museum of Art: A Catalogue of Works by Artists Born between 1816 and 1845*, vol. 2, New York: Metropolitan Museum of Art, 1985, pp. 60-65.

CHRISTIAN SCHUSSELE
1824-1879

7. *King Solomon and the Iron Worker*, 1863
Oil on canvas
44 x 62¼ in. (111.8 x 158.1 cm)
Funds provided by an anonymous donor, 1990.15

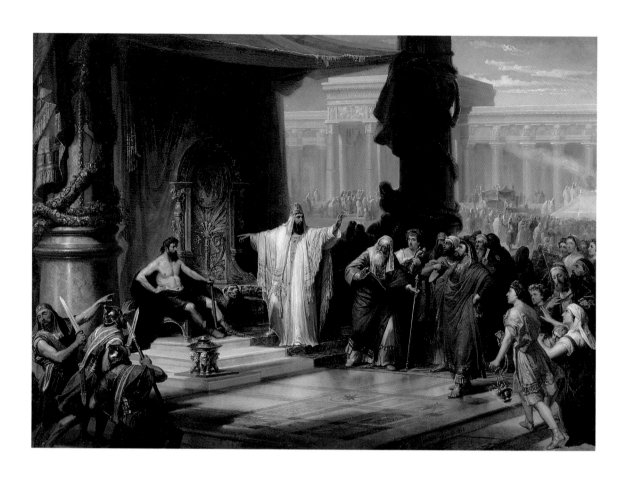

DANIEL HUNTINGTON
1816-1906

8. *Mercy's Dream*, 1841
Oil on canvas
84½ x 66½ in. (214.6 x 168.9 cm)
Bequest of Henry C. Carey (The Carey Collection),
1879.8.10

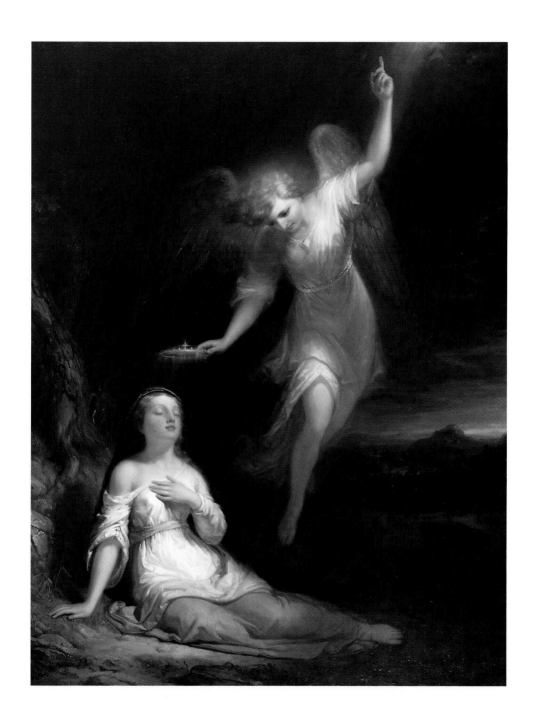

9. *Gil Blas Securing the Cook in the Robbers' Cave*, 1812
Oil on canvas
83¾ x 53¹³/₁₆ in. (212.7 x 136.7 cm)
Pennsylvania Academy purchase, 1855.2

Known today as one of Philadelphia's leading nineteenth-century portraitists, Thomas Sully was admired during his lifetime as an accomplished history painter, as well. His best-known work of this genre is *Washington at the Passage of the Delaware* of 1819 (Museum of Fine Arts, Boston), a monumental scene from the American Revolution. Sully similarly employed a large format in this earlier work, based on the popular French novel *Gil Blas de Santillane*. The novel, written by Alain Le Sage in 1715, appeared in several editions in England and the United States between 1790 and 1820. A particularly dramatic episode (book 1, chapter 10) describes the encounter between the novel's hero, Gil Blas, and a band of Spanish brigands. In this work, Sully depicts the moment when Gil Blas ties up the robbers' cook, steals her key, and escapes with a beautiful young woman, Donna Mencia.

Le Sage's narrative inspired a number of romantic paintings by both British and American artists in the early nineteenth century, most notably John Opie (1761-1807) and Washington Allston (1779-1843). Sully's 1812 painting is a copy of an earlier work by Opie, perhaps the version exhibited at the Royal Academy in London in 1804. Sully was introduced to such European literary subjects when he studied with Benjamin West (1738-1820) in England in 1809-10. The dramatic quality of the scene, with its emphasis on exaggerated facial expression and effects of spotlighting, underscores the theatricality of Anglo-American history painting of this period. Sully capitalized on the relationship between theater and painting in his many portraits of well-known actors and actresses, several of which were exhibited and acquired by the Pennsylvania Academy, including *George Frederick Cooke as Richard III*, 1811-12 (fig. 5), and *Frances Anne Kemble as Bianca*, 1833.

Both Opie's painting and Sully's copy were exhibited at the Pennsylvania Academy in May of 1816. (The former was added to the Academy's permanent collection by bequest in 1842, the latter by purchase in 1855.) Yet another version of this scene, by Washington Allston, *Donna Mencia in the Robbers' Cave*, 1815 (Museum of Fine Arts, Boston), was shown at the Academy in September of the same year. Subjects drawn from *Gil Blas de Santillane* appeared in American art as late as 1849 in the work of the narrative painter Francis Edmonds (1806-1863).

REFERENCES:

Ada Earland, *John Opie and His Circle*, London: Hutchinson and Co., 1911, pp. 346-347.

Edward Biddle and Mantle Fielding, *Life and Works of Thomas Sully*, Philadelphia: Wickersham Press, 1921, no. 2259.

Christopher M. S. Johns, "Theater and Theory, Thomas Sully's *George Frederick Cooke as Richard III*," *Winterthur Portfolio* 18, (Spring 1983), pp. 28-38.

10. *The Murder of Rutland by Lord Clifford*, 1815
Oil on canvas
96¾ x 79½ in. (245.7 x 202 cm)
Gift of the Leslie Family, 1831.1

At an early age, Charles Robert Leslie was apprenticed to the Philadelphia booksellers Bradford and Inskeep, who sold engravings of European art and instilled in the boy a strong literary interest that was to remain with him throughout his career as a painter. In his autobiography, Leslie recalled a pivotal event in his teens when he went to see the British actor George Frederick Cooke, playing in Shakespeare's *Richard III* on the Philadelphia stage in 1811. Impressed with Cooke's skill as an actor, the young Leslie executed a few sketches of the great man and studied a full-length portrait of him by Thomas Sully (fig. 5). Both Leslie's sketches and the Sully portrait were exhibited at the Pennsylvania Academy in 1811; and, after viewing Leslie's sketches, several Philadelphia gentlemen took up a collection to send the fledgling artist to London.

A letter of introduction from Sully to London's leading history painter, Benjamin West (1738-1820), enabled Leslie to study with West. During the evenings he sketched antique casts at the Royal Academy. Leslie also frequented the London theater and became an admirer of John Kemble and Sarah Siddons, two of Britain's most renowned and often painted Shakespearean actors. Leslie's first major work during this period was this painting, a dramatic scene from Shakespeare's *Henry VI*, Part Three (act 1, scene 3). It depicts the death of the young earl of Rutland at the hands of his father's enemy during the War of the Roses. This civil war, which gripped England between 1455 and 1471, was the result of a bitter dispute over the throne between the royal houses of York and Lancaster. Rutland, the son of the duke of York, was brutally murdered by Lord Clifford, who then presented his blood-soaked handkerchief to the boy's father to wipe away his tears.

Leslie's tragic scene is related to a long tradition of British theatrical portraits stemming from Francis Hayman's famous *David Garrick as Richard III* of 1760 (National Theater, London). Kneeling on a stormy battlefield, clad in armor and raising a dagger, the murderous Clifford assumes the same pose and mad demeanor of Richard III in the Hayman portrait. Other visual sources that may have influenced the young Leslie in this ambitious composition were the many engraved illustrations of Boydell's *Shakespeare Gallery*, published in several editions in the first decade of the nineteenth century and widely available in Europe and the United States. In addition, there are a number of Renaissance and baroque paintings and prints of the Sacrifice of Isaac from the Old Testament, which may have served as a source for the painting's composition.

The horrific romanticism of this work is derived from the contrast between the demonic Clifford and his angelic young victim, whose features are said to have been modeled on those of the English artist Edward Lear, a fellow student at the Royal Academy. This kind of exaggerated emotion is typical of English romantic painting of the period. It is evident in the work of Henry Fuseli, an instructor at the Royal Academy, and in paintings by Leslie's mentor, Washington Allston (1779-1843). Allston taught the young Leslie about the color techniques of Venetian painters such as Titian and the figural arrangements of Raphael, two artists whose grand-manner painting is evident in Allston's art (see fig. 4). The connections between Allston and Leslie were certainly recognized by the Pennsylvania Academy, as the work of these two expatriate artists was featured in special exhibitions throughout the first half of the nineteenth century.

REFERENCES:

Charles Robert Leslie, *Autobiographical Recollections*, Boston: Ticknor and Fields, 1860.

James Dafforne, *Pictures by Charles Robert Leslie, R.A.*, London: Virtue and Co., 187[?].

THOMAS SULLY
1783-1872

9. *Gil Blas Securing the Cook in the Robbers' Cave*, 1812
Oil on canvas
83¾ x 53¹³⁄₁₆ in. (212.7 x 136.7 cm)
Pennsylvania Academy purchase, 1855.2

10. *The Murder of Rutland by Lord Clifford*, 1815
Oil on canvas
96¾ x 79½ in. (245.7 x 202 cm)
Gift of the Leslie Family, 1831.1

EUROPEAN THEMES

CHARLES R. LESLIE
1794-1859

11. *Touchstone, Audrey, and the Clown in "As You Like It,"*
ca. 1831
Oil on paper, mounted on wood
11 1/8 x 15 3/4 in. (28.3 x 40 cm)
Bequest of Henry C. Carey (The Carey Collection),
1879.8.16

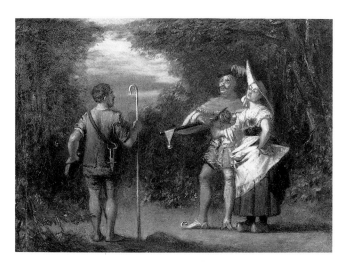

Charles Robert Leslie specialized in popular literary themes drawn from Shakespeare, Molière, Cervantes, and Fielding. This painting and several of his other works were given to the Pennsylvania Academy by members of the Carey family, prominent writers and publishers in nineteenth-century Philadelphia. One of the artist's sisters was married to Henry Carey; and another sister, Eliza Leslie, was a writer whose works were published by the firm of Carey and Hart (see cat. no. 22).

Based on a scene from Shakespeare's *As You Like It* (act 5, scene 1), this work is more intimate in scale and far less imposing than Leslie's earlier painting *The Murder of Rutland by Lord Clifford* (cat. no. 10). The artist's stylistic approach here differs also, lighter in the handling of paint and color, closer to the French eighteenth-century rococo style that Leslie admired. In his writings about art, Leslie characterized Antoine Watteau's work as "transcendent." His own art exhibited a wide-ranging taste for narrative subjects that included not only the elegant pastoral fantasies (*fêtes galantes*) of the previous century but also the bawdy peasant scenes of seventeenth-century Dutch painters. He recommended a similarly broad spectrum of tastes to art students in *A Hand-Book for Young Painters* of 1855, a copy of which was in the Pennsylvania Academy's library in the nineteenth century and may well have influenced the artist William Emlen Cresson (see cat. no. 12), who depicted Shakespearean subjects in the 1860s.

REFERENCES:

Charles Robert Leslie, *A Hand-Book for Young Painters*, London: John Murray, 1855, pp. 51-63 and 230-253.

Frank H. Goodyear Jr., "The Carey Collection," in *The Beneficent Connoisseurs*, exhib. cat., Philadelphia: Pennsylvania Academy of the Fine Arts, 1974 (unpaginated).

Gervase Jackson-Stops, "The Sources for the Paintings of Charles R. Leslie," *Antiques* 135 (Jan. 1989), pp. 310-321.

12.  *Falstaff*, 1866
Oil on canvas
14 1/8 x 12 1/4 in. (35.9 x 31.1 cm)
Bequest of Priscilla P. Cresson, 1902.1.3

The work of William Emlen Cresson, a young painter of much promise who died at the age of twenty-five, exemplifies the strong interest in literary subjects that continued in Philadelphia through the nineteenth century. Cresson was from a prominent Quaker family interested in art and education. A precocious artist, he first exhibited his work at the Pennsylvania Academy's annual exhibition of 1854 at the age of eleven. The subject of that painting, a Christmas scene, set the stage for his production of other narrative works relying on elements of fantasy and caricature. Here, the choice of the comic character Falstaff provided the humor and the historical costuming that were typical of Cresson's approach to literary subjects. While there is no dramatic action in the scene, the rounded belly, scowling expression, and prominent display of tankard and sword suggest the raucous nature of this popular Shakespearean character.

Falstaff, the hard-drinking buffoon who appears in several of Shakespeare's plays about the lives of Henry IV and Henry V, kings of England between 1399 and 1422, was the subject of many prints and paintings produced in the late eighteenth and nineteenth centuries. For example, there are several Falstaff images among the prints published in Boydell's *Shakespeare Gallery*, one of the best-known sets of English prints distributed in this country, and in the work of Charles R. Leslie (see cat. nos. 10 and 11), the expatriate Philadelphian who exhibited *Falstaff [Im]personating the King* (location unknown) at the Royal Academy in London in 1851. In Philadelphia during this period, Shakespeare's plays about the Plantagenet kings and their military exploits played regularly to full houses; and the character of Falstaff would have been well known to local audiences through both paintings and stage productions.

REFERENCE:

Catherine Stover, "A Historical Account of William Emlen Cresson, 1843-1868, and the Cresson Awards at the Pennsylvania Academy of the Fine Arts," *In This Academy* (Spring-Summer 1983), p. 9.

EUROPEAN THEMES

EMANUEL LEUTZE
1816-1868

13.  *The Poet's Dream*, by 1840
Oil on canvas
30⁵⁄₁₆ x 25¼ in. (77 x 64.1 cm)
Bequest of Henry C. Carey (The Carey Collection),
1879.8.17

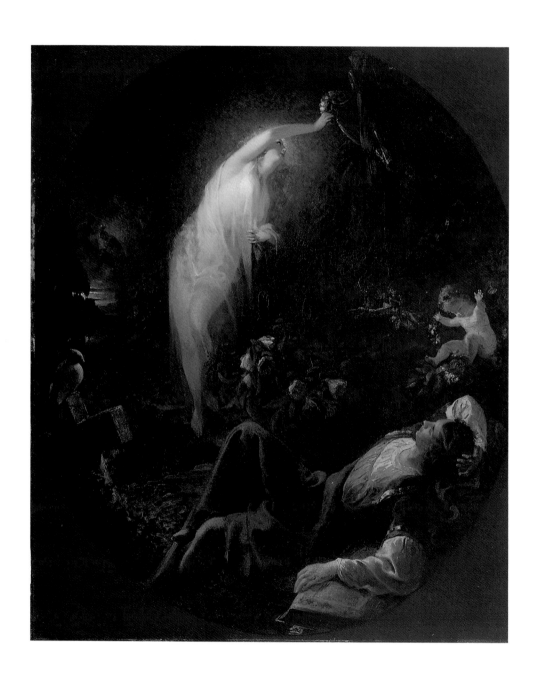

PETER FREDERICK
ROTHERMEL
1812-1895

14. *De Soto Raising the Cross on the Banks of the*
*Mississippi,* 1851
Oil on canvas
40 x 50 in. (101.6 x 127 cm)
Henry C. Gibson Fund and Mrs. Elliott R. Detchon,
1987.31

13. *The Poet's Dream,* by 1840
Oil on canvas
30⅝₁₆ x 25¼ in. (77 x 64.1 cm)
Bequest of Henry C. Carey (The Carey Collection),
1879.8.17

The preeminent American history painter of
the nineteenth century, Emanuel Leutze
received his early artistic training in Philadel-
phia from John Rubens Smith (1775-1849),
an English-born engraver. By 1836 Leutze
had begun to exhibit with members of the
Artists' Fund Society at the Pennsylvania
Academy. *The Poet's Dream,* exhibited there
in 1841, was one of his earliest mature works
and demonstrates his romantic sensibilities
and interest in literary subjects. Although
there is no known text as its source, the paint-
ing deals with the subject of poetic inspira-
tion. Traditionally, nine Greek muses were
thought to preside over learning and the cre-
ative arts; and they were a favorite subject of
Renaissance artists. Here, the young poet,
asleep in a graveyard, is visited by an appari-
tion in thin, filmy drapery. She places a
wreath of flowers on his lyre, the ancient
Greek instrument used by poets to accom-
pany the recitation of their verses. Probably
intended to be Erato, the muse of lyric poetry,
she hovers above the poet and illuminates his
body with the light of inspiration. Assisted in
her actions by a cherub, the muse reiterates
the ceremonial crowning that occurs in the
poet's dream depicted among the clouds in
the far distance of the painting.

Leutze's taste for literary themes drew
the attention of the Philadelphia art collector
Edward L. Carey, who came from a family of
distinguished writers and publishers. The
Carey family collection featured narrative
paintings, many based on European literary
themes, including works by Charles R. Leslie
(see cat. nos. 10 and 11) and Daniel Hunting-
ton (see cat. no. 8). Eventually, this interest in
European literary subjects drew the artist
back to his native Germany, where he studied
further at the Düsseldorf Academy in the
1840s. In addition to literary subjects, Leutze
was encouraged to turn to narrative themes
drawn from events in English and American
history. He later produced his best-known
works in this genre, *Washington Crossing the
Delaware,* 1851 (Metropolitan Museum of
Art, New York) and his mural for the Capi-
tol, *Westward the Course of Empire Takes Its
Way,* 1861-62.

REFERENCES:

Anna Wells Rutledge, *The Annual Exhibition Record of
the Pennsylvania Academy of the Fine Arts, 1807-1870,*
Madison, Ct.: Sound View Press, 1988, p. 129.

Barbara S. Groseclose, *Emanuel Leutze, 1816-1868: Free-
dom Is the Only King,* Washington, D.C.: Smithsonian
Institution Press, 1975, no. 12.

PETER FREDERICK
ROTHERMEL
1812-1895

14. *De Soto Raising the Cross on the Banks of the Mississippi*, 1851
Oil on canvas
40 x 50 in. (101.6 x 127 cm)
Henry C. Gibson Fund and Mrs. Elliott R. Detchon, 1987.31

Images of early colonial exploration became increasingly popular in the mid-nineteenth century as westward expansion of the white population brought renewed conflict with native-American tribes. Peter Rothermel's painting celebrating the Christianization of the New World by the Spanish explorer Hernando de Soto (ca. 1500-1542) reinforced the prevailing ideology of manifest destiny, which justified white expansion at the expense of native-American life. De Soto, who came to the Americas in search of gold, led the first European expedition to the Mississippi River in 1541. His troops are remembered today for their cruel treatment of the native population, whom they tortured, enslaved, and killed.

Rothermel's image is based not on actual fact but is rooted in the history of art. Its origins can be traced to Benjamin West's *Penn's Treaty with the Indians* of 1771-72 (fig. 8), a painting that Rothermel certainly would have known through popular prints. Rothermel's stylistic approach was influenced by the emotionally charged paintings of the baroque period, especially the art of Peter Paul Rubens. The theme, composition, and interest in color in this painting in particular echo portions of Rubens's famous altarpiece *The Raising of the Cross* 1610 (Antwerp Cathedral).

During the 1840s and 1850s, Rothermel rose to prominence in the field of history painting with other works that depicted scenes of New World exploration, such as the conquest of Mexico by Cortez, the adventures of Christopher Columbus, and the landing of the Pilgrims. *De Soto Raising the Cross on the Banks of the Mississippi*, commissioned by the famous actor Edwin Forrest, typifies Rothermel's approach to narrative painting; he invests the subjects with a romantic sense of theatricality by using grand gestures, historical costuming, and well-orchestrated groupings of figures. While Rothermel's ambitious combination of European style

and American historical subjects was appreciated by mid-nineteenth-century audiences, it gradually fell out of favor by the end of the century.

REFERENCE:

Mark Thistlethwaite, "Peter F. Rothermel: a forgotten history painter," *Antiques* 124 (Nov. 1983), pp. 1016-1022.

MICHELE FELICE CORNÈ
1752-1845

15. *The Landing of the Pilgrims*, ca. 1807
Oil on canvas
36⁹/₁₆ x 52⅛ in. (92.9 x 132.4 cm)
Gift of Mrs. Henry S. McNeil in loving memory of
her husband, Henry S. McNeil, 1985.46

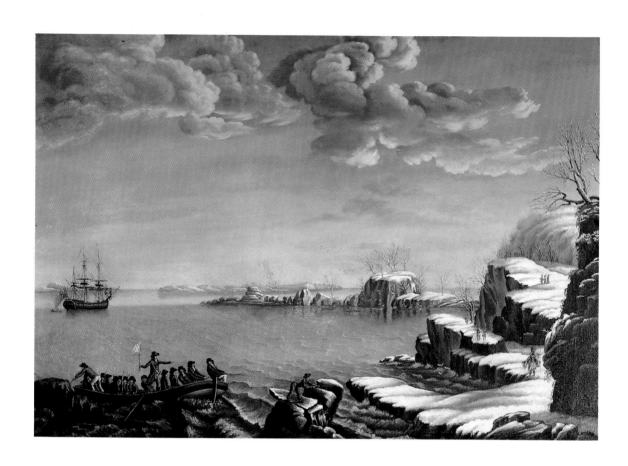

EDWARD SAVAGE
1761-1817

16. *William Penn's Treaty with the Indians,* ca. 1800
Oil on canvas
38⁵/₁₆ x 52³/₁₆ in. (97.3 x 132.6 cm)
Gift of the Philadelphia Electric Company, 1976.5

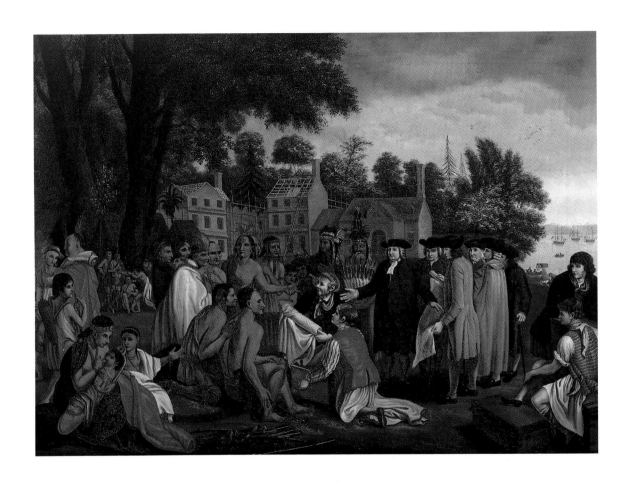

15. *The Landing of the Pilgrims,* ca. 1807
Oil on canvas
36⁹/₁₆ x 52⅛ in. (92.9 x 132.4 cm)
Gift of Mrs. Henry S. McNeil in loving memory of
her husband, Henry S. McNeil, 1985.46

Michele Felice Cornè was born on the island of Elba and probably trained as an artist in Naples. He came to the United States in 1800 aboard a Salem, Massachusetts, merchant vessel. This painting illustrates the legend of the first English settlers to arrive at Plymouth Rock in December of 1622. The rocky shoreline depicted bears little resemblance to the mud flats and marshes that surrounded the actual site of the landing. Cornè took further liberties with the scene, adding figures of native Americans on the shore and a British man-of-war, rather than the *Mayflower*, at anchor in the distance. According to seventeenth-century accounts, there were no native Americans present during the initial landing. Moreover, the uniforms of the sailors in the small boat date from the late eighteenth century. These historical inaccuracies, however, heighten the drama of Cornè's scene by suggesting the harshness of the New World and the possibility for armed conflict that still existed in his day.

Cornè's image is derived from a print by Samuel Hill (active 1789-1803) engraved for a celebration of the 180th anniversary of the landing, organized by descendants of the Pilgrims in 1800. Throughout the nineteenth century, the image saw widespread use by many artists for commemorative events on inexpensive Chinese export paintings, on Staffordshire china, and on fireboards for East India Marine Hall (now the Peabody Museum) in Salem, Massachusetts. Cornè himself painted at least six versions of this popular historical subject in addition to numerous marine views and landscapes.

In Boston during the War of 1812, Cornè held a public exhibition of naval battle scenes.

A few years later, he also made copies of marine paintings by Thomas Birch (see cat. no. 18) for Abel Bowen's *The Naval Monument* published in Boston in 1816. Other narrative paintings by Cornè based on popular legends drawn from American history include scenes of the story of Columbus, a subject also depicted by the Philadelphia artist Peter Rothermel (see cat. no. 14).

REFERENCES:

Carl L. Crossman and Charles R. Strickland, "Early depictions of the Landing of the Pilgrims," *Antiques* 98 (Nov. 1970), pp. 777-781.

*Michele Felice Cornè*, *1752-1845*, exhib. cat., Salem, Ma.: Peabody Museum, 1972.

16. *William Penn's Treaty with the Indians*, ca. 1800
Oil on canvas
38⁵⁄₁₆ x 52³⁄₁₆ in. (97.3 x 132.6 cm)
Gift of the Philadelphia Electric Company, 1976.5

Edward Savage was a Boston engraver and painter who studied in London with Benjamin West (1738-1820) and later settled in Philadelphia between 1795 and 1801. In Philadelphia he exhibited a popular panorama of London and made portrait prints of American military and political leaders such as General Anthony Wayne, George Washington and his family, and Thomas Jefferson. This image of the founding of Pennsylvania by William Penn is copied from a print of West's famous work of 1771-72 (fig. 8) by John Hall, published in 1775 and widely distributed in the United States. Both the print and Savage's painting reverse the composition but otherwise faithfully reproduce the details of West's image. West's recreation of this legendary event spawned numerous copies in the late eighteenth and early nineteenth centuries in a wide variety of media – prints, linen handkerchiefs, plates, and even jigsaw puzzles.

As the meeting between Penn and the Indians probably never occurred, West's inventive composition should be understood as an artistic allegory of colonial expansionism, not as a record of an actual event. According to the legend, in 1682 a group of Quakers met with the leaders of the Lenni Lanape, or Delaware tribes, under a great elm tree at Shackamaxon on the Delaware River in Pennsylvania to sign the first legal peace agreement between the European settlers and the native-American population. In West's image, William Penn stands at the head of the Quaker group, holding a map of the region; merchants display their goods to the native Americans in the foreground while other members of the tribe gather around to observe their chiefs negotiating the settlement. Certain details in the background, such as the architectural style of the houses and the harbor full of ships, are anachronistic, more representative of Philadelphia almost a century after the event.

By the 1770s when William Penn's son

Thomas commissioned West to paint this subject, the Quakers, merchants, and Lenni Lenape were at odds with one another over the issue of land ownership. West's image of peaceful cohabitation directly served the political and economic needs of his patron who still retained many proprietary rights in Pennsylvania and was seeking to extend his authority over both the Quakers and the native population. By 1810, when Savage made his copy of West's work, the national appeal of the legend had begun to fade as western expansion moved beyond the Appalachian Mountains. But in Pennsylvania the story of Penn's Treaty maintained a strong hold on local historical tradition and on Quaker religious beliefs, reemerging in the folk paintings of Edward Hicks (see cat. no. 17).

REFERENCES:

Mantle Fielding, *Dictionary of American Painters, Sculptors, and Engravers*, Poughkeepsie, N.Y.: Apollo Books, 1983, pp. 819-820.

Anthony N. B. Garvan, "The Consequence: The Social Impact of Benjamin West's Painting," in *Symbols of Peace: William Penn's Treaty with the Indians*, exhib. cat., Philadelphia: Pennsylvania Academy of the Fine Arts, 1976, no. 9.

Ann Uhry Abrams, "Benjamin West's Documentation of Colonial History: *William Penn's Treaty with the Indians*," *Art Bulletin* 64 (March 1982), pp. 59-75.

EDWARD HICKS
1780-1849

17. *The Peaceable Kingdom,* ca. 1833
Oil on canvas
17⅞ x 23¹⁵⁄₁₆ in. (45.4 x 60.8 cm)
John S. Phillips bequest, by exchange (acquired
from the Philadelphia Museum of Art, originally
the 1950 bequest of Lisa Norris Elkins), 1985.17

THOMAS BIRCH
1779-1851

18. *Perry's Victory on Lake Erie,* ca. 1814
Oil on canvas
66 x 96½ in. (167.6 x 245.1 cm)
Gift of Mrs. Charles H. A. Esling, 1912.15

17. *The Peaceable Kingdom*, ca. 1833
Oil on canvas
17⅞ x 23¹⁵/₁₆ in. (45.4 x 60.8 cm)
John S. Phillips bequest, by exchange (acquired
from the Philadelphia Museum of Art, originally
the 1950 bequest of Lisa Norris Elkins), 1985.17

Edward Hicks was a Quaker folk artist, whose choice of narrative subjects was inextricably linked to his religious beliefs. Born in Bucks County, Pennsylvania, he began his career as a coach and sign painter; but he eventually sought out more complex landscape, history, and religious subjects. In over one hundred variations on the biblical theme of the Peaceable Kingdom produced between 1820 and 1849, Hicks gradually evolved a complex religious iconography that reflected the Quaker ideals of peace, harmony, and love, as well as specific issues that emerged from the theological debates between orthodox Quakers and the Hicksites, or Separatists, during this period. Along with his relative Elias Hicks, who was the leader of the Separatist movement, the artist was active as a Quaker preacher. He believed that salvation was achieved by attaining a state of inner light rather than by experiencing the more traditional Christian rite of communion.

Hicks's belief in the importance of inner light is especially evident in this version of the Peaceable Kingdom. Here, he combined narrative elements from the Bible (*Isaiah* 11: 6-8) with the famous Quaker legend of William Penn signing the peace treaty with the Indians (see fig. 8 and cat. no. 16). The foreground of Hicks's painting provides a detailed illustration of the biblical text:

*The wolf shall dwell with the lamb,*
*and the leopard shall lie down with the kid,*
*and the calf and the lion and the fatling*
    *together,*
*and a little child shall lead them.*
*The cow and the bear shall feed;*
*and their young shall lie down together;*
*and the lion shall eat straw like the ox.*
*The suckling child shall play over the hole of*
    *the asp,*
*and the weaned child shall put his hand on the*
    *adder's den.*

In later images of the Peaceable Kingdom such as this one, the peaceful lion with his glowing mane, radiating whiskers, and branches of barley grain between its teeth represents the nonviolent, vegetarian way of life. Like the sun, the lion symbolizes the Hicksite belief in inner light. While earlier versions of this theme were based more closely on an English print by Richard Westall, later ones reflect Hicks's personal interpretation of the biblical text. Many of the original frames for the Peaceable Kingdom paintings were incised with quotes from a poem by Hicks based on the biblical text, which he circulated with the painting.

REFERENCES:

Eleanor Price Mather and Dorothy Canning Miller, *Edward Hicks: His Peaceable Kingdoms and Other Paintings*, New York: Cornwall Books, 1983.

Alice Ford, *Edward Hicks: His Life and Art*, New York: Abbeville Press, 1985.

18. *Perry's Victory on Lake Erie*, ca. 1814
Oil on canvas
66 x 96½ in. (167.6 x 245.1 cm)
Gift of Mrs. Charles H. A. Esling, 1912.15

This unusually large work by Thomas Birch depicts a famous naval battle between the United States and Great Britain during the War of 1812. In one of the few American victories of that war, Commander Oliver Hazard Perry and his small fleet defeated a British naval force at the western end of Lake Erie. Afterwards, Perry is said to have reported, "We have met the enemy and they are ours." The patriotic fervor associated with this event is suggested by the grand scale of Birch's painting and the prominent display of the American flag in the foreground. When the painting was exhibited at the Pennsylvania Academy during the war, in May of 1814, the catalogue entry identified each vessel, noted the number of guns it carried, and announced that prints by Alexander Lawson (1773-1846) after the painting were for sale. Birch continued to capitalize on the political sentiment of the day and painted at least fifteen different naval battles from this war.

Although Birch chose contemporary American events, his depictions closely followed the tradition of naval battle scenes in seventeenth-century Dutch and eighteenth-century English art. Trained as an artist by his English-born father, William, who was an engraver, Birch may have seen such images in European prints, readily available in Philadelphia in the early nineteenth century. Birch and his father first worked together to produce topographical landscapes of Philadelphia, but gradually Thomas began to specialize in marine views. In scenes of naval battles and in even more romantic images of storm-tossed ships, Birch counted on the associative powers of the viewer to link the image with romantic stories of heroic conflict between nations or between man and nature.

REFERENCES:

William H. Gerdts, *Thomas Birch*, exhib. cat., Philadelphia: Philadelphia Maritime Museum, 1966.

John Wilmerding, *American Maritime Painting*, New York: Harry N. Abrams, 1987, pp. 74-82.

AMERICAN THEMES

JAMES HAMILTON
1819-1878

19. *Old Ironsides*, 1863
Oil on canvas
60⅜ x 48 in. (153.4 x 121.9 cm)
Gift of Caroline Gibson Taitt, 1885.1

**BASS OTIS**

1784-1861

20. *Interior of a Smithy*, ca. 1815
Oil on canvas
50⅝ x 80½ in. (128.6 x 204.5 cm)
Gift of the artist, 1845.2

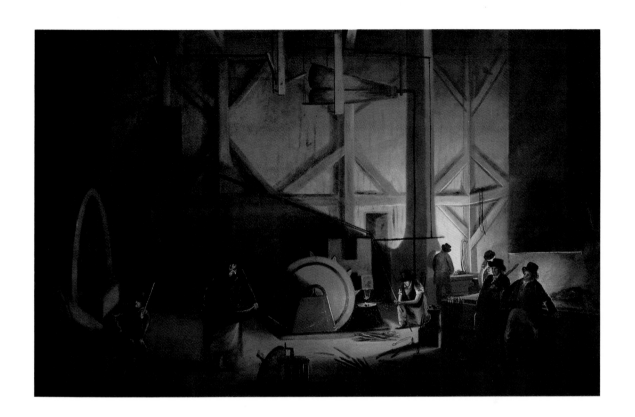

19. *Old Ironsides*, 1863
Oil on canvas
60⅜ x 48 in. (153.4 x 121.9 cm)
Gift of Caroline Gibson Taitt, 1885.1

This romantic image of the U.S.S. *Constitution*, popularly known as "Old Ironsides" because of its steadfastness during the War of 1812, is based on a poem of the same title penned by Oliver Wendell Holmes. The poem was written in 1830 to arouse public support for the old ship, which was about to be dismantled; and the last eight lines of the poem, inscribed on the back of the canvas, pleaded for her natural death at sea:

*O better that her shattered hulk*
*Should sink beneath the wave;*
*Her thunders shook the mighty deep,*
*And there should be her grave;*
*Nail to the mast her holy flag,*
*Set every threadbare sail,*
*And give her to the god of storms –*
*The lightning and the gale!*

Fortunately, popular sentiment of the day was strong; and "Old Ironsides" is preserved to this day as a national monument in Boston harbor.

Hamilton's choice of narrative subject and style was influenced by the marine paintings of the contemporary English artist J. M. W. Turner. He, like Hamilton, often appended parts of poems to his paintings; and he achieved great fame for his stormy sea pictures rendered with loosely applied brushstrokes and dramatic effects of light. Another contemporary influence on Hamilton's choice of this particular subject was undoubtedly the American Civil War. The preservation of the American "Ship of State," symbolized in Hamilton's painting by the tattered flag, was the ideological aim of the Union cause.

REFERENCES:

Arlene Jacobowitz, *James Hamilton, 1819-1878: American Marine Painter*, exhib. cat., Brooklyn: Brooklyn Museum, 1966.

Bruce W. Chambers, "James Hamilton, 'Old Ironsides,' The Shipwreck as Apocalyptic Propaganda: Notes and a Tentative Conclusion," (unpublished paper, 1971), Archives of Pennsylvania Academy.

20. *Interior of a Smithy*, ca. 1815
Oil on canvas
50⅝ x 80½ in. (128.6 x 204.5 cm)
Gift of the artist, 1845.2

Bass Otis's painting of a blacksmith shop was described in the catalogue for the 1815 annual exhibition at the Pennsylvania Academy as "A Foundry in New England with Operatives, Machinery, etc." Although there is no documentary evidence linking this picture with any specific site, it is possible that the work is based on Otis's early experience as an apprentice scythe-maker in New England. His father, Josiah, was a blacksmith who eventually owned a mill for manufacturing nails and tacks. In any case, the work is historically important because it is the first major painting to deal with an industrial subject in American art.

The unusual nocturnal setting, large scale, and choice of subject relate this painting to the work of the eighteenth-century English painter Joseph Wright of Derby. Wright's popular scenes of rural English blacksmith shops, such as *An Iron Forge* of 1772 (Lord Romsey, Broadlands Collection), were engraved and distributed in the United States. Otis received his artistic training in New York between 1808 and 1812 from another English artist and printmaker, John Rubens Smith (1775-1849), the grandson of Thomas Smith of Derby, a landscape painter. John Rubens Smith encouraged his pupils to learn to draw in the academic manner by studying European prints and antique casts.

Like Wright, Otis aggrandizes this scene of everyday life by highlighting the new mechanical forge in the center of the composition. The power-driven machine and the laborers who ran it represent the new forces of the Industrial Revolution, which was just beginning to take hold in the United States after the War of 1812. Although Otis worked primarily as a portrait painter after this date, he produced two industrial scenes of the Delaware River Valley about 1840, *Landscape of Eleutherian Mills* (Hagley Museum, Wilmington) and *Brandywine Mills* (The Historical Society of Delaware, Wilmington).

REFERENCE:

Gainor P. Davis and Wayne Craven, *Bass Otis: Painter, Portraitist, and Engraver*, exhib. cat., Wilmington: Historical Society of Delaware, 1976.

AMERICAN THEMES

21. *Country Wedding, Bishop White Officiating,*
probably 1814
Oil on canvas
16³/₁₆ x 22⅛ in. (41.1 x 56.2 cm)
Gift of Paul Beck, Jr., 1842.2.1

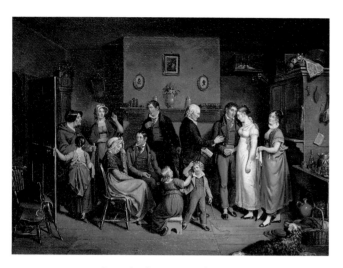

Born in Germany, John Lewis Krimmel studied art there before settling in Philadelphia in 1810. Perhaps the first American artist to earn a living by painting scenes of everyday life, Krimmel established genre painting as an academically acceptable alternative to history painting at the Pennsylvania Academy. His choice of traditional artistic sources for the style and narrative theme of *Country Wedding, Bishop White Officiating* certainly reflects his European training. While the clothing and decor depicted in this quaint scene of American rural life are characteristic of the period, the overall composition of the picture and many of the details reveal Krimmel's use of a wide range of art-historical precedents.

The most immediate source for this work is the art of Sir David Wilkie, a contemporary Scottish painter whose genre subjects were exhibited to popular acclaim at the Royal Academy in London. Krimmel exhibited his own painted copy of a Wilkie print, *The Blind Fiddler*, 1812 (Berry-Hill Galleries, Inc., New York), at the Pennsylvania Academy's annual exhibition in 1813. That work is strikingly similar to *Country Wedding*, with the shallow interior space divided into three principal areas and the hearth serving as the focal point of the composition. These paintings

also share incidental details, such as the cupboard with household utensils to the right and the dog placed near baskets and earthenware jugs in the foreground. Many of these seemingly minor details in the Krimmel painting reinforce a traditional iconographic reading of this nuptial scene. For example, the billing and cooing doves in the bird cage represented human love in seventeenth-century Dutch paintings; the faithful dog ("Fido" from the Latin *fides*, or faith) can be found in early Netherlandish paintings, such as Jan Van Eyck's *The Betrothal of the Arnolfini*, 1434 (National Gallery, London); and the water jugs and wine glasses refer to the New Testament parable of the wedding feast at Cana, a scene often depicted in medieval and Renaissance art.

For American audiences in the nineteenth century, however, it was important that genre scenes reflect not only an understanding of the history of art but also recognizable local customs and personalities. An article published with a print of *Country Wedding* called it "a true portraiture of nature in real, rustic life" (*Analytic Magazine* 1 [1820], p. 175). Krimmel's inclusion of the silhouette portraits of George and Martha Washington over the mantlepiece certainly served to identify this work as an American scene. By the 1860s, the figure of the old minister was thought to be William White (1743-1836), the first Episcopal bishop of Pennsylvania. Although his features are similar to those of the bishop, there is no documentary evidence that Krimmel intended his image to be a portrait.

REFERENCES:

Catherine Hoover, "The Influence of David Wilkie's Prints on the Genre Paintings of William Sidney Mount," *American Art Journal* 13 (Summer 1981), pp. 5-33.

Milo Naeve, *John Lewis Krimmel, An Artist in Federal America*, Newark: University of Delaware Press, 1987, pp. 86-97 and 110-111.

22. *The Ghost Story,* by 1840
Oil on canvas
17 9/16 x 16 13/16 in. (44.6 x 42.7 cm)
Bequest of Henry C. Carey (The Carey Collection),
1879.8.2

George H. Comegys was born in Maryland and studied with the Philadelphia portrait painter John Neagle (1796-1865). Although little is known about Comegys's life, in the 1840s he exhibited several small paintings at the Pennsylvania Academy that are rich in narrative content. His work appealed especially to the Philadelphia art collector Edward L. Carey, who purchased this painting and published it as an illustration to a short story in his popular annual, *The Gift*. Like many of the paintings reproduced as prints in Carey's gift books, the images came first and the story followed (see cat. nos. 23-25).

The author of the story that accompanied the Comegys print was Eliza Leslie, sister of the romantic painter Charles R. Leslie (see cat. nos. 10 and 11). She specialized in children's fiction and for this image invented a complicated tale-within-a-tale, involving a tattered but treasured book about the mysterious adventures of an itinerant painter.

Four boys find the old book, written by their former schoolmaster, and eagerly begin to read the tale aloud in their favorite hideaway in a barn. As night falls, they reach the most frightening part of the ghost story – the moment depicted in Comegys's painting. "Just then three knocks were heard at the door, and a start and a cry of terror from all the boys. The latch was heavily lifted, and the cry became a scream as they all sprang forward and huddled together, falling on each other." The story concludes with the entrance of their schoolmaster, who reassures the frightened boys that his tale is pure fiction.

The boys in the story, as well as readers of Miss Leslie's tale, were meant to experience the sense of suspense and terror that were hallmarks of romantic art. Comegys's painting, in turn, conveys that same romantic sensibility through the children's expressions. The narrative message in both the story and the painting suggests the power of art to transform human emotions; ultimately these works encouraged literacy and promoted the pleasure of aesthetic experience for children.

REFERENCES:

Miss [Eliza] Leslie, "The Ghost-Book, A Story of the Last Century," in *The Gift*, Philadelphia: Carey and Hart, 1840, pp. 294-309.

Anna Wells Rutledge, *The Annual Exhibition Record of the Pennsylvania Academy of the Fine Arts, 1807-1870*, Madison, Ct.: Sound View Press, 1988, p. 51.

Mantle Fielding, *Dictionary of American Painters, Sculptors, and Engravers*, Poughkeepsie, N.Y.: Apollo Books, 1983, p. 179.

23. *Mumble-the-Peg*, 1842
Oil on canvas
24⅛ x 20⅛ in. (61.3 x 51 cm)
Bequest of Henry C. Carey (The Carey Collection),
1879.8.13

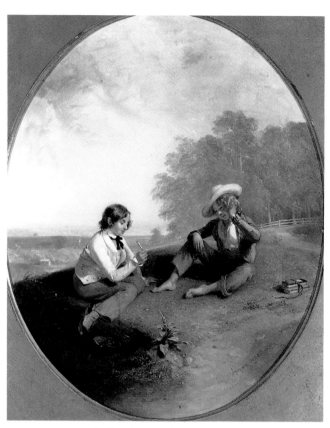

In the nineteenth century, Henry Inman was highly regarded as a genre painter and acknowledged as one of the first American artists to specialize in such scenes of everyday life. Inman's choice of narrative themes, often based on the popular stories of the contemporary writers James Fenimore Cooper and Washington Irving published in the *Knickerbocker* magazine, reflects his interest in the literary culture of New York state. An original composition, Inman's *Mumble-the-Peg*, in turn inspired a tale called "The Story of Nick Ten Vlyck," which is reminiscent of Knickerbocker folktales filled with childhood dreams and devilish apparitions.

The author, George Fenno Hoffman, claimed that he recalled the story after seeing Inman's painting in the artist's studio. In his tale, two boys, one wealthy and the other poor, engaged in an earnest game of mumble-the-peg, which demanded knife-throwing skill. A poor throw resulted in the penalty of having to pull, or mumble, a wooden peg from the ground with one's teeth. Nick, the country boy, was an avid reader of ghost stories and the books at his side help account for his overly active imagination, which comes into play as the narrative unfolds.

Unable to free the peg from the ground, Nick falls asleep in a graveyard and dreams of a strange impish character with long ears, clad in medieval doublet and hose. The game of mumble-the-peg and the boy's foolish nightmare become intertwined in the story, but eventually Nick awakens the victor, with the peg gripped firmly in his teeth. The romanticism of this story and the idyllic vision of childhood presented in the Inman painting serve to idealize this genre scene, even for a nineteenth-century audience. But it is a humbler, homegrown form of romanticism, drawn from the ordinary events of American life rather than from the more grandiose visionary aspects of European culture.

REFERENCES:

George Fenno Hoffman, "Inman's Picture of Mumble-the-Peg with the Story of Nick Ten Vlyck," in *The Gift*, Philadelphia: Carey and Hart, 1844, pp. 44-61.

William H. Gerdts, "Henry Inman: Genre Painter," *American Art Journal* 9 (May 1977), pp. 26-48.

William H. Gerdts, *The Art of Henry Inman*, exhib. cat., Washington, D.C.: National Portrait Gallery, 1987, pp. 51, no. 64.

WILLIAM PAGE
1811–1885

24.   *The Young Merchants,* 1842
Oil on canvas
42⅛ x 36¼ in. (107 x 92.1 cm)
Bequest of Henry C. Carey (The Carey Collection),
1879.8.19

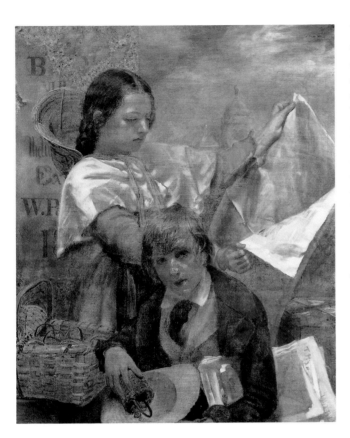

William Page was an ambitious painter who specialized in classical and religious subjects, as well as portraiture. In *The Young Merchants,* one of his rare genre scenes, Page explores another aspect of narrative painting, the depiction of contemporary urban life. Scenes of city children marketing goods can be traced back to seventeenth-century Dutch and eighteenth-century English painting, but Page firmly locates this work in mid-nineteenth-century New York by the inclusion of details such as the cupola of City Hall, built between 1802 and 1812, and the *New World* masthead on the newspaper. A critic for this New York paper later praised the painting for its naturalness and its ability to convey the freshness of the outdoors, two qualities that further enhanced the accessibility of the subject matter for a wide audience.

Like several other genre paintings acquired by Edward L. Carey in the 1840s (see cat. nos. 22, 23, and 25), this work was engraved as a book illustration. It depicts a moral tale about the goodness of rural life versus the degradation of life in the city. The pivotal moment in the tale is this scene in which the young girl reads in the paper that the boy's family farm is for sale. Pooling their meager savings from the sale of newspapers and fresh produce, the two enterprising children buy back the farm and rescue their families from poverty. Certainly the lessons about perseverance, hard work, and literacy conveyed in this image were of great relevance to American viewers in the age of Jacksonian democracy.

REFERENCES:

*New World* 5, no. 14 (Oct. 1, 1842), p. 223.

Seba Smith, "The Young Traders," in *The Gift,* Philadelphia: Carey and Hart, 1844, pp. 221–254.

Joshua C. Taylor, *William Page, The American Titian,* Chicago: University of Chicago Press, 1957, pp. 36–40, no. 15.

JAMES G. CLONNEY
1812-1867

25. *Militia Training*, 1841
Oil on canvas
28 x 40 in. (71.1 x 101.6 cm)
Bequest of Henry C. Carey (The Carey Collection),
1879.8.1

ATTRIBUTED TO
WILLIAM JAMES STILLMAN
1828-1901

26.  *Union Soldiers in Camp*, ca. 1861
     Oil on canvas
     12⁹⁄₁₆ x 20 in. (31.9 x 50.8 cm)
     Gift of Mr. and Mrs. Edward Kesler, 1975.20.8

25. *Militia Training*, 1841
Oil on canvas
28 x 40 in. (71.1 x 101.6 cm)
Bequest of Henry C. Carey (The Carey Collection),
1879.8.1

The most complicated of Clonney's genre paintings, *Militia Training* owes its narrative and compositional structure to precedents in British art. Despite such overtly American elements as the patchwork quilt over the beer stand, the prominent display of the American flag, and the dancing minstrels, the overall conception of this scene is derived almost directly from Sir David Wilkie's painting *The Pitlessie Fair* of 1804 (National Gallery of Scotland, Edinburgh). However, Clonney worked hard on the small details in this painting. The unusual number of preparatory drawings for individual figures, such as the dancing figure in the center (Museum of Fine Arts, Boston) relate Clonney's work to the American genre subjects of William Sidney Mount. In rural scenes such as this, Mount and Clonney often included images of African Americans dancing and playing the fiddle. These paintings helped established a common stereotype that idealized African-American life in the nineteenth century.

Of further relevance for American viewers in the nineteenth century was the moralizing tale that appeared with an engraving of this painting in the 1843 edition of *The Gift*. This annual Christmas book was published by Edward L. Carey, the owner of Clonney's painting and several other American genre scenes (see cat. nos. 22-24). The gift book story focuses on an incident that occurred in a small New England town during the annual fall muster of the local militia, the scene depicted in the Clonney painting.

The hero of the story, an honest woodsman named Jerry, had invested his small savings in beer and gingerbread to stock the food tent for the great event. During the festivities, his young friend George tickles one of the inebriated revelers with a straw, the scene at the far left. George is then attacked by the drunkard's brother, who is shown crawling after his military hat at the right. In the ensuing melee, Jerry's arm is broken; the tent and his hoped-for profits destroyed. Young George later repays Jerry for his losses with money that he earns for memorizing his Greek primer. Several years later, as an adult, George again saves Jerry from financial ruin. This moralizing tale of temperance, education, and generosity to one's neighbors transforms this genre painting from a mere copy of European artistic forms into a plea for substantive American values.

REFERENCES:

John Frost, "The Militia Training, or One Good Turn Deserves Another," in *The Gift*, Philadelphia: Carey and Hart, 1843, pp. 195-208.

Lucretia H. Giese, "James Goodwyn Clonney (1812-1867): American Genre Painter," *American Art Journal* 11 (Oct. 1979), pp. 4-31.

Guy C. McElroy, *Facing History: The Black Image in American Art, 1710-1940*, exhib. cat., Washington, D.C.: Corcoran Gallery of Art, 1990, p. 39.

AMERICAN THEMES

26. *Union Soldiers in Camp*, ca. 1861
Oil on canvas
12⁹/₁₆ x 20 in. (31.9 x 50.8 cm)
Gift of Mr. and Mrs. Edward Kesler, 1975.20.8

A quiet, peaceful moment in wartime, this scene of a militia training camp contains a variety of narrative elements: children at play, men relaxing in front of a cabin, and a line of marching soldiers. The composition is comparable to Clonney's more animated painting of a similar subject (cat. no. 25). Except for the American flag and the small figure of an armed sentry beyond it in the woods, direct references to the war are minimized. The thirty-four stars in the flag, denoting the number of states that made up the Union between 1861 and 1863, indicate that the painting was probably executed at the beginning of the Civil War. At the time when battles were few and far between, camp followers were many; and sometimes spectators even carried picnic baskets and field glasses to watch the military action.

The painting has been attributed to William Stillman, an artist involved in the Pre-Raphaelite art movement, which espoused a high degree of realism and attention to detail. Active as both a painter and photographer, Stillman often focused on quiet scenes of nature, especially woodland scenes in the Adirondack Mountains. Although he lived abroad much of his adult life, Stillman returned to the United States to marry in 1860. With the outbreak of the Civil War, he visited several Union regiments in an attempt to enlist. During the summer of 1861, he produced a few paintings of camp life similar to this work in both style and content. After failing to enter the army, Stillman took up a career as a diplomat and journalist.

REFERENCES:

Frances Miller, *Catalogue of the William James Stillman Collection*, Schenectady, N.Y.: Friends of the Union College Library, 1974.

Linda S. Ferber and William H. Gerdts, *The New Path, Ruskin and the American Pre-Raphaelites*, exhib. cat., Brooklyn: Brooklyn Museum, 1985, p. 277.

WILLIAM B. T. TREGO
1859-1909

27.  *Battery of Light Artillery en Route*, 1882
Oil on canvas
30⅛ x 64⅛ in. (76.5 x 162.9 cm)
Gift of Fairman Rogers, 1883.4

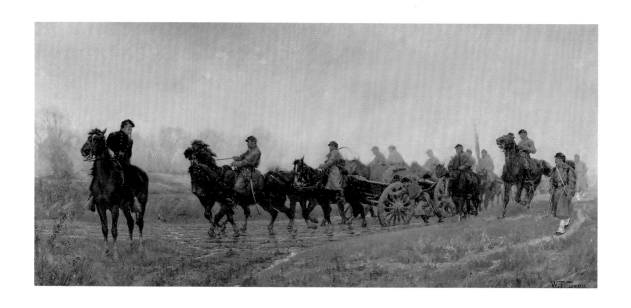

WILLIAM MERRITT CHASE
1849-1916

28. *"Keying Up" – The Court Jester*, 1875
Oil on canvas
39¾ x 25 in. (101 x 63.5 cm)
Gift of the Chapellier Galleries, 1969.37

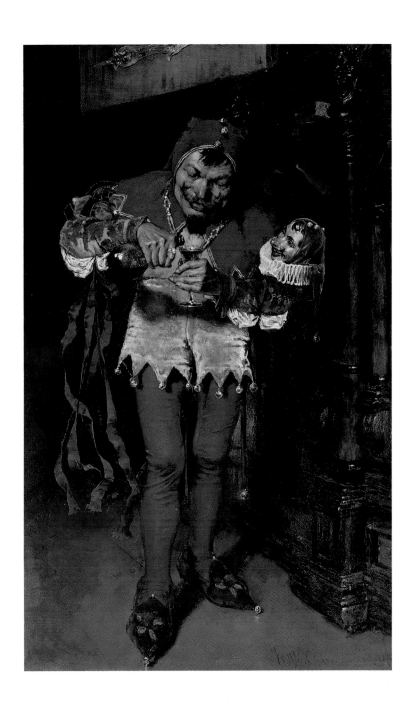

27. *Battery of Light Artillery en Route, 1882*
Oil on canvas
30⅛ x 64⅛ in. (76.5 x 162.9 cm)
Gift of Fairman Rogers, 1883.4

William Trego's Civil War scene emphasizes the ordeal of a winter march rather than the drama of battle. An artist who was especially fond of horses, Trego depicts them here as beasts of burden, whose straining bodies and animated faces convey the physical hardship of military life experienced by man and animal alike. His approach to narrative painting, which relies on exactness of historical detail and expression but not any specific event, is typical of late-nineteenth-century American art. Trego's interest in military subjects ranges from the American Revolution to the Franco-Prussian War, but his Civil War scenes were the most popular. Awarded a prize at the 1882 annual exhibition of the Pennsylvania Academy, this work was purchased by Fairman Rogers, one of Philadelphia's leading art patrons and an avid horseman.

Fairman Rogers is perhaps best known for his support of Thomas Eakins (1844-1916), Trego's teacher at the Pennsylvania Academy between 1879 and 1882. Eakins taught both animal and human anatomy at the Academy and urged his students to concentrate on the realistic rendering of physical form. The subdued gray palette in this work suggests the influence of Eakins, whose own paintings became increasingly somber after the 1880s. During this period, Walt Whitman's popular Civil War poems also provided a literary parallel to Trego's work. Both painter and poet emphasized in explicit and vivid detail the suffering of the ordinary soldier. Trego, who himself was physically handicapped, must have sympathized greatly with such physical adversity.

REFERENCE:

Helen Hartman Gemmill, "William B. T. Trego: the artist with paralyzed hands," *Antiques* 124 (Nov. 1983) pp. 994-999.

WILLIAM MERRITT CHASE
1849-1916

28. *"Keying Up" – The Court Jester*, 1875
Oil on canvas
39¾ x 25 in. (101 x 63.5 cm)
Gift of the Chapellier Galleries, 1969.37

A medal winner at the 1876 Centennial Exhibition in Philadelphia, this early work by William Merritt Chase established his reputation as an artist in America. It was painted in Munich, where Chase studied at the Royal Academy of Art and where such humorous costumed scenes were especially popular. The jester in Chase's painting, fortifying himself, or keying up, with a drink before his comic antics, is rendered with the artist's characteristic concern for color. The prevailing red not only enlivens the work but also underscores the jester's inebriated state, suggested by his prominent red nose. As if that were not enough, the fool's head that the jester carries replicates his prominent features with the same ruddy coloring. The homeliness of their human faces is further mocked by the grotesque demon masks above them on the Renaissance-style cabinet.

Fools were known as great mimics, and Chase himself was often praised for his skill in emulating a wide variety of colors and textures in the objects he painted. In this work, his ability to simulate the tactile quality of sumptuous textiles, polished surfaces of wood, and gleaming metalwork fools the eye and delights the viewer, much in the same way that a jester amuses by mimicking facial expressions and gestures. This was a subject that Chase depicted a number of times in paintings. He also reproduced the image as an etching in the late 1870s. It may have had an impact on the work of Thomas Shields Clarke (see cat. no. 29), who also displays a similar interest in elaborate costume and historical setting in his image of a court jester.

The image of the jester has a long tradition in the history of art, dating back to antiquity. He is identified by his grotesque features and comic attire, which often includes a hat with bells and a long stick with a small fool's head at one end. His role as a comic figure in medieval court life gradually changed over the centuries; and, by the nineteenth century, he had become a stock figure on the stage. Shakespeare's Falstaff (see cat. no. 12) is a variant of the character of the fool, whose mockery and comic antics were tolerated even by kings.

REFERENCES:

E. Tietze-Conrat, *Dwarfs and Jesters in Art*, London: Phaidon Press, 1957.

Ronald G. Pisano, *William Merritt Chase, A Leading Spirit in American Art*, exhib. cat., Seattle: Henry Art Gallery, University of Washington, pp. 29 and 40.

THOMAS SHIELDS CLARKE
1860-1920

29.  *Fool's Fool*, 1887
Oil on canvas
39½ x 83 in. (100.3 x 210.8 cm)
Gift of Charles J. Clarke, 1888.1

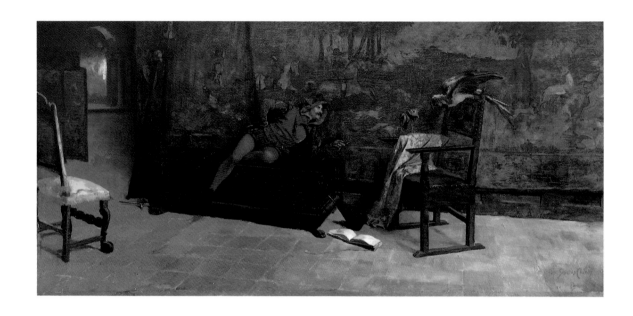

THOMAS HOVENDEN
1840-1895

30.  *The Favorite Falcon*, 1879
Oil on canvas
53⅝ x 38¾ in. (136.2 x 98.4 cm)
Gift of Mrs. Edward H. Coates (The Edward H.
Coates Memorial Collection), 1923.9.1

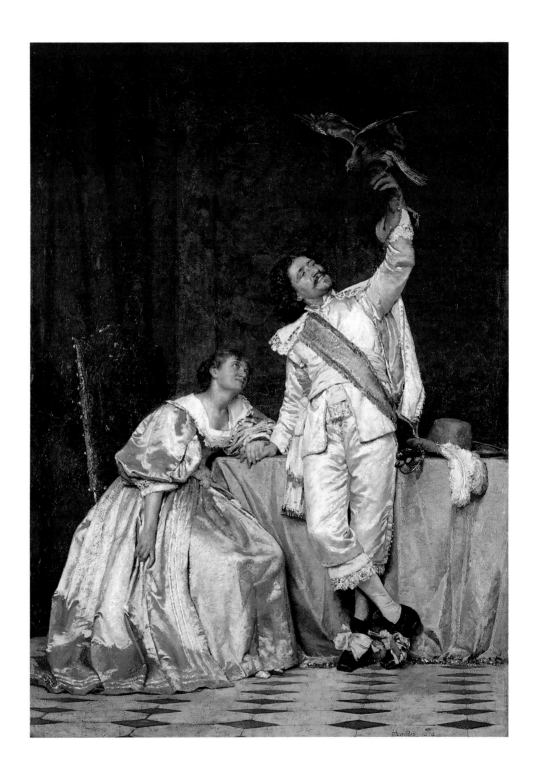

29.  *Fool's Fool*, 1887
Oil on canvas
39½ x 83 in. (100.3 x 210.8 cm)
Gift of Charles J. Clarke, 1888.1

Like his better-known contemporary William Merritt Chase (see cat. no. 28), Thomas Shields Clarke outfitted his elegant painting studio with medieval tapestries and armor, Renaissance furniture, oriental ceramics, and Middle Eastern metalwork. Many of these decorative objects appear in Clarke's painting *Fool's Fool* and are even emulated in the painting's original frame, which incorporates grotesque heads into the four corners. Rather than portraying a specific narrative character, Clarke evokes a generalized feeling of nostalgia for the past. In costume pieces especially, he focuses attention on dreamy figures often posed in a contemplative stance – the historical past suggested in their classical or medieval garb.

Clarke, the son of a wealthy Pittsburgh businessman, received a liberal arts education at Princeton University before he turned to painting. He took classes briefly at the Art Students League in New York in 1878, but most of his artistic education took place in Paris, first at the Académie Julian and later at the Ecole des Beaux-Arts. He studied with the leading French academic painters of his day, Jules Lefebvre, Gustave Boulanger, Jean-Léon Gérôme, and Pascal-Adolphe-Jean Dagnan-Bouveret. Clarke adopted their popular realist style and penchant for historical subjects.

Traveling throughout Europe in the late 1880s and 1890s, he lived in Rome, Florence, and Venice, as well as Paris. During this period, he exhibited paintings and sculpture at international exhibitions in Berlin, Madrid, and London. This work, painted in Florence, was shown at the Paris Salon of 1887 and at the World's Columbian Exposition in Chicago in 1893. Its acceptance in popular exhibitions such as these, in both Europe and the United States, suggests the

great appeal that this kind of escapist subject matter had in the midst of increasing industrialization and urbanization in the late nineteenth century.

Realist artists, academically trained like Clarke, often brought their skills to bear on such fanciful historical subjects rather than contemporary life, because these scenes conveyed the sense of privilege and erudition adopted by the upper classes. Clarke, who came from a well-to-do family with cosmopolitan tastes, never had to support himself by selling art and could indulge his private flights of fancy.

REFERENCES:

W. A. Cooper, "Artists in their Studios: William H. Howe, Miss Clara T. McChesney, Thomas Shields Clarke, Vergilio Tojetti," *Godey's Magazine* 130 (May 1885), pp. 469-475.

Arthur Hoeber, "Thomas Shields Clarke," *Brush and Pencil* 6 (August 1900), pp. 193-198.

THOMAS HOVENDEN
1840-1895

30. *The Favorite Falcon*, 1879
Oil on canvas
53⅝ x 38¾ in. (136.2 x 98.4 cm)
Gift of Mrs. Edward H. Coates (The Edward H.
Coates Memorial Collection), 1923.9.1

A romanticized scene of seventeenth-century aristocratic life, Thomas Hovenden's painting depicts an elegantly attired couple admiring a falcon. The falcon, or hawk, noted for its long tail and distinctive pattern of flight, had been used in hunting sports by European nobility since the Middle Ages. The sentimental nature of Hovenden's subject is conveyed in the ardent gaze of the young woman, who looks up admiringly at the bird, while gently clasping the hand of the handsome cavalier. The luxuriousness of their clothing and the gracefulness of their interlocked poses add elegance to Hovenden's composition.

This painting was executed in France where Hovenden had gone to study in 1874. He worked in the Paris studio of the academic figure painter Alexandre Cabanal and outdoors at Pont-Aven on the Brittany coast with other young American artists, including Robert Wylie (see cat. no. 37). Like many artists of the post-Civil War generation, Hovenden selected narrative subjects that appealed to both European and American audiences. *The Favorite Falcon* was exhibited at the Pennsylvania Academy in 1888, soon after Hovenden had succeeded Thomas Eakins (1844-1916) as an instructor at the school. Like Eakins, Hovenden ultimately concentrated on scenes of American life; today he is best known for genre paintings of the Civil War and African-American domestic scenes.

REFERENCE:

Lee M. Edwards, "Noble Domesticity: The Paintings of Thomas Hovenden," *American Art Journal* 19 (1987) pp. 4-38.

FRANK LeBRUN KIRKPATRICK
1853-1917

31.   *Venetian Palace*, 1883
      Oil on canvas
      29 x 60 in. (73.7 x 152.4 cm)
      Gift of Mr. and Mrs. Walter H. Rubin in memory of
      Abraham Rubin, 1978.14

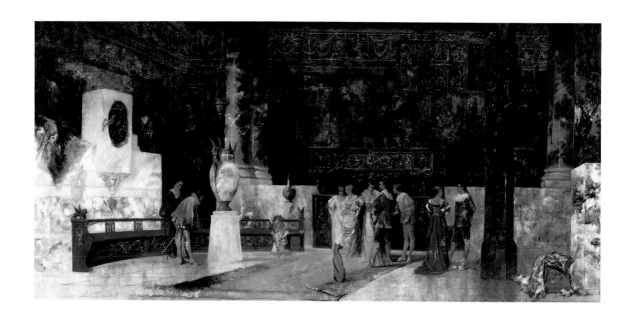

EDWARD HARRISON MAY, JR.    32.   *Dying Brigand*, 1855
1824-1887                              Oil on canvas
                                              64 x 90 in. (162.6 x 228.6 cm)
                                              Pennsylvania Academy purchase, by subscription,
                                              1857.3

31.  *Venetian Palace*, 1883
Oil on canvas
29 x 60 in. (73.7 x 152.4 cm)
Gift of Mr. and Mrs. Walter H. Rubin in memory of
Abraham Rubin, 1978.14

During the late nineteenth century, the Philadelphia artist Frank LeBrun Kirkpatrick was noted for his depiction of luxurious historical interiors. Based more on his imagination than on actual settings, his paintings are filled with the rich textures and colors of marble, elegant costumes in satin and lace, and ornate decorative schemes. Kirkpatrick dazzled his viewers with both the ostentatiousness of such scenes and his skill as a trompe l'oeil painter. *Trompe l'oeil*, a French term for "fools the eye," was a heightened form of realistic painting especially popular in American art between 1880 and 1900. Kirkpatrick, who was also a mural painter, used this technique to trick viewers into believing the reality of objects that were only a painted illusion. Kirkpatrick probably learned this technique while studying at the Royal Academy in Munich during the 1870s.

Kirkpatrick's *Venetian Palace* pays homage to the trompe l'oeil tradition in seventeenth-century Italian art. During the baroque period in Italy, painting, architecture, sculpture, as well as the decorative arts, sought to overpower the viewer with the dynamic use of curves, elaborate ornamentation, rich materials, and ingenious illusionism. These elements are all present in Kirkpatrick's scene, and they transport the viewer from the ordinary world into an imaginary setting. While the small winged lions on the bench, symbols of the city of Venice, suggest the locale of this painting, it is similar to other Kirkpatrick paintings that depict a museum in Seville, Spain. These paintings were exhibited at the Pennsylvania Academy and praised by contemporary critics for their technical skill and rich color.

Kirkpatrick's fanciful costume pictures rely on a strong element of historical fantasy, as do works by other American artists trained at the Royal Academy in Munich in the 1870s, such as William Merritt Chase (see cat. no. 28). While the full extent of Kirkpatrick's work is not known today, his obituary noted that in the late nineteenth century "the private galleries and museums of many wealthy men in the East [were] the product of the brush of Mr. K" (*Philadelphia Ledger*, Nov. 18, 1917). The association of wealth, power, and the art of the baroque period in Kirkpatrick's work must have had great appeal for wealthy patrons in America's Gilded Age. They were, no doubt, attracted by the aura of aristocratic connoisseurship that emanates from Kirkpatrick's paintings.

REFERENCE:

Peter Hastings Falk, ed., *The Annual Exhibition Record of the Pennsylvania Academy of the Fine Arts, 1876-1913*, Madison, Ct.: Sound View Press, 1988, p. 287.

EDWARD HARRISON MAY, JR.
1824-1887

32. *Dying Brigand*, 1855
Oil on canvas
64 x 90 in. (162.6 x 228.6 cm)
Pennsylvania Academy purchase, by subscription,
1857.3

Long forgotten, *Dying Brigand* in its day was a much lauded painting. It won a gold medal at the Paris exposition of 1855 and received critical acclaim when at the annual exhibition at the Pennsylvania Academy in 1856. In order to purchase the work, the directors of the Academy issued special stock shares to encourage donors. The narrative theme of May's work, the death of an Italian brigand, or thief, was first popularized in the works of the seventeenth-century Italian artist Salvator Rosa, who inspired many early-nineteenth-century American romantic painters, including Benjamin West (see fig. 2), Washington Allston (see fig. 3), and Thomas Cole (1801-1848). Thomas Sully's narrative painting *Gil Blas Securing the Cook in the Robbers' Cave* (cat. no. 9) is yet another example of the popularity of this theme in the nineteenth century.

The robber in May's painting is identified by his gun and colorful costume, typical of those worn by Italian peasants. The pallor of his haggard face contrasts sharply with the more robust features of the Italian peasant girl who has led him to the foot of a crucifix bearing a skull and crossbones. With her eyes turned upwards, she no doubt pleads for his redemption. The intense gaze of the dying brigand and the large scale of this painting first attract the attention of the viewer, who only gradually discovers the religious message of the scene in examining the details.

May began his studies as an artist in New York in the 1840s under the direction of Daniel Huntington, another American narrative painter who worked in the grand manner of the Old Masters. During this period, May worked on a large panorama *The Pilgrim's Progress*, a popular religious subject also painted by Huntington (cat. no. 8). By 1851, May had moved to Paris, where he entered the studio of Thomas Couture, one of the most noted history painters of the period. Couture's influence can be seen not only in May's choice of a narrative subject but also in

the range of hues in his palette and the use of localized color.

May remained in Paris for most of his career but exhibited at the Pennsylvania Academy for a decade between 1856 and 1867. Many of the paintings that he showed during those years were based on scenes of English history, such as his painting *Lady Jane Grey, as She Goes to Execution, Gives Her Tablets as a Remembrance to the Constable of the Tower*, ca. 1863 (Woodmere Art Museum, Philadelphia), purchased by the prominent Philadelphia collector Joseph Harrison, Jr. This painting, in its choice of melodramatic subject, is similar to the theme of execution explored in Julian Story's painting *Marie Charlotte Corday* (cat. no. 33).

REFERENCES:

Anna Wells Rutledge, *The Annual Exhibition Record of the Pennsylvania Academy of the Fine Arts, 1807-1870*, Madison, Ct.: Sound View Press, 1988, pp. 138-139.

*Dictionary of American Biography*, vol. 6, New York: Charles Scribner's Sons, 1936, pp. 446-447.

JULIAN STORY
1857-1919

33. *Marie Charlotte Corday,* 1889
Oil on canvas
99 x 79 in. (251.5 x 200.7 cm)
Gift of Mrs. Julian Story, 1946.15

JOHN McLURE HAMILTON
1853-1936

34. *Tears*, 1879
Oil on wood
7¾ x 4¹⁵/₁₆ in. (19.7 x 12.5 cm)
Gift of Mr. and Mrs. John McLure Hamilton, 1936.24

33. *Marie Charlotte Corday,* 1889
Oil on canvas
99 x 79 in. (251.5 x 200.7 cm)
Gift of Mrs. Julian Story, 1946.15

Painted during the centennial of the French Revolution, this work dramatizes a scene in the life of the famous assassin Charlotte Corday, who was guillotined in 1793 for the murder of Jean Paul Marat. The leader of the radical Jacobin party, Marat had imprisoned many members of the more moderate Girondist faction and unleashed a wave of bloody violence in Paris known as the Reign of Terror. In response, Corday, an aristocratic supporter of the Girondists, stabbed Marat to death in his bathtub. One of the best-known historical paintings produced during the Revolution was *Marat Assassinated,* 1793 (Musées Royaux des Beaux-Arts, Brussels) by Jacques-Louis David, a scene of Marat as victim, lying dead in his tub.

Reversing the emotional sympathies of David's work, Story shows Corday after her arrest and hasty trial, about to be led to her execution by a red-capped Jacobin. The melodrama of Story's scene is heightened by Corday's upward glance to heaven and the peasant woman who prays for her soul in the background. The audience is further compelled to confront this image of martyrdom because of its monumental size. Story thus utilizes two elements of the romantic style, emotionalism and grand scale, to overwhelm his viewer.

The son of William Wetmore Story, a noted American neoclassical sculptor, the painter would have learned of the romantic tradition firsthand as the family lived abroad. Educated at Oxford University in England, Story later studied academic painting in Paris with Gustave Boulanger and Jules Lefebvre. A member of an international set of expatriate American artists, Story exhibited both in Europe and in the United States. He showed another scene of the French Revolution, based on Lamartine's *History of the Girondins,* at the Paris Salon in 1887 and at the Pennsylvania Academy the following year. After that date, he turned more frequently to portraiture.

REFERENCES:

Peter Hastings Falk, ed., *Who Was Who in American Art,* Madison, Ct.: Sound View Press, 1985, p. 601.

Peter Hastings Falk, ed., *The Annual Exhibition Records of the Pennsylvania Academy of the Fine Arts, 1876-1913,* Madison, Ct.: Sound View Press, 1988, pp. 458-459.

JOHN McLURE HAMILTON
1853-1936

34.  *Tears*, 1879
Oil on wood
7³/₄ x 4¹⁵/₁₆ in. (19.7 x 12.5 cm)
Gift of Mr. and Mrs. John McLure Hamilton, 1936.24

Like many artists of the late nineteenth century, John McLure Hamilton led a very cosmopolitan existence. The Jamaican-born artist studied at the Pennsylvania Academy of the Fine Arts in 1870, the Royal Academy in Antwerp, the Ecole des Beaux-Arts in Paris and eventually settled in London. He exhibited at most of the major international expositions at the turn of the century and at the annual exhibitions of the Pennsylvania Academy between 1884 and 1926. Both his portrait paintings and his genre scenes are marked by fluid brushwork and an attention to detail that belie his rapid handling of paint. These important details of clothing and interior design often provide indications of social status or narrative interest in his paintings.

*Tears*, a painting that Hamilton described as a portrait of his wife "so tired and homesick that she began to cry," is more than a personal anecdote. The bouquet and the letter on the floor in the foreground, the blossoms on the table, and the weeping figure dressed in a ball gown strongly suggest a romantic association. While the painter re-creates a precise emotional moment, viewers are encouraged to relate that particular psychological state to their own experience of love and perhaps rejection. The elegance of the sitter's long curving pose and her fancy dress certainly appealed to a feminine audience at whom such narrative genre scenes were aimed. The intimate scale of the painting with its precise but flowing brushwork demanded the kind of close scrutiny that this work would receive in a domestic, rather than a public, setting.

REFERENCES:

Peter Hastings Falk, ed., *Who Was Who in American Art*, Madison, Ct.: Sound View Press, 1985, p. 258.

Peter Hastings Falk, ed., *The Annual Exhibition Record of the Pennsylvania Academy of the Fine Arts, 1876-1913*, Madison, Ct.: Sound View Press, 1988, pp. 230-231. See also correspondence with the artist in the files of the Pennsylvania Academy.

GILDED AGE FANTASIES

35. *Old Timers,* 1882
Oil on canvas
15⅞ x 11¹⁵⁄₁₆ in. (40.3 x 30.3 cm)
Gift of Mrs. Charles B. Hahs, 1895.2.1

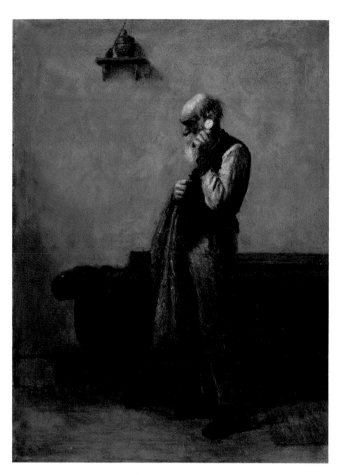

Virtually nothing is known about the short life of the Philadelphia artist Philip B. Hahs. He was a student at the Pennsylvania Academy for several years between 1876 and 1882, when Thomas Eakins (1844-1916) was in charge of instruction at the school. Hahs provided one of the illustrations for the 1879 *Scribner's* magazine article "The Art Schools of Philadelphia." His was a scene of Pennsylvania Academy students making drawings of casts of classical sculpture. He showed this illustration along with several landscapes at the Academy's annual exhibition that same year. The two works by Hahs now in the Academy's collection, however, are figural works, both depicting the same elderly gentleman. *Old Timers,* with its punning title referring to both the old man and his pocket watch, alludes to the passage of time, as well as the history of American genre painting.

Several of the compositional elements in this work link Hahs's painting to one of the most important American genre paintings in the Pennsylvania Academy's collection, William Sidney Mount's *The Painter's Triumph* of 1838 (fig. 7). The simplicity of the background and emphasis on the profile of the model's head in Hahs's work are reminiscent of Mount's painting, which Hahs would have encountered when it entered the collection with the Carey bequest in 1879. Hahs's interest in cast drawing during that year would have made him particularly aware of the similar concerns expressed in Mount's picture. Moreover, close scrutiny of Hahs's painting reveals a pentimento, or change, that the artist made while working on this canvas. The faint outlines of a Windsor chair, the kind included in the Mount painting, are still visible just to left of the figure. While Mount clearly established the realist tradition in American genre painting, it was a tradition that continued to be refined in Philadelphia in the art of Thomas Eakins (1844-1916). During the late 1870s, Eakins was engaged in a series of works based on old-fashioned colonial subjects, such as spinning and weaving. Hahs, as a student of Eakins, was clearly influenced by his teacher. The plainness of the background, the cropped view of the empire settee, and the gentle portrayal of old age in this work relate to much of Eakins's art in painting, as well as photography, during this period.

REFERENCE:

Peter Hastings Falk, ed., *The Annual Exhibition Record of the Pennsylvania Academy of the Fine Arts, 1876-1913,* Madison, Ct.: Sound View Press, 1988, p. 227.

WILLIAM HENRY LIPPINCOTT
1849-1920

36. *Childish Thoughts*, 1895
Oil on canvas
32¼ x 45¹¹⁄₁₆ in. (81.9 x 116.1 cm)
Gift of Mary H. Rice, 1976.3

A Philadelphia native, William Henry Lippincott received his initial training as an artist at the Pennsylvania Academy of the Fine Arts. He continued his studies in Paris during the 1870s with the figurative artist Léon Bonnat. Lippincott exhibited at the annual Paris Salons, which favored his realistically rendered genre scenes of upper-middle-class life. On returning to the United States in 1884, he established a studio in New York and taught at the National Academy of Design, another institution that encouraged a detailed, realist approach to painting. In addition to portraits and landscapes, Lippincott showed genre scenes, such as this work, at the annual exhibitions of the National Academy of Design and the Pennsylvania Academy.

*Childish Thoughts* in many ways relates to Lippincott's early years in Philadelphia. After the centennial exposition held in Philadelphia in 1876, a revival of interest in American colonial life swept the country. It was especially strong in Philadelphia, which took pride in the role it had played in promoting both the arts and mercantile interests during the late eighteenth century. This sense of historical pride is evident in Lippincott's domestic interior, which features furniture, paneling, a portrait painting, and even costumes that suggest the colonial era. The ship

model on the mantle may allude to the mercantile interests that provided the wealth necessary to sustain the genteel lifestyle depicted in the painting. The three generations of females give further narrative focus to Lippincott's composition. Each is occupied in a pursuit that represents the idealized role played by women of leisure in contemporary Victorian society: the grandmother knits at ease by the fireside, the young mother entertains at the piano, and the child plays with her doll, thus carrying on the maternal tradition. These references to a colonial heritage, upperclass wealth, and appropriate gender roles made the picture socially relevant to the wellto-do, conservative audiences who patronized Lippincott's art.

REFERENCE:

Lee M. Edwards, *Domestic Bliss: Family Life in American Painting, 1840-1910*, exhib. cat., Yonkers, N.Y.: Hudson River Museum, 1986, pp. 96-98.

GILDED AGE FANTASIES

ROBERT WYLIE
1839-1877

37. *The Postman*, 1868
Oil on canvas
46⅛ x 57¾ in. (117.2 x 146.7 cm)
Gift of Desna and Herman Goldman, 1984.34

Between 1859 and 1862, Robert Wylie studied figure drawing and sculpture at the Pennsylvania Academy of the Fine Arts. Among his fellow students during those years were other figure painters such as Daniel Ridgway Knight (see cat. no. 41), Mary Cassatt (see cat. no. 4), and Thomas Eakins (1844-1916), who like Wylie all went abroad for further academic training. While in France, Wylie enrolled at the Ecole des Beaux-Arts, exhibited genre paintings at the annual Paris Salons, and traveled to Pont-Aven on the Brittany coast to paint scenes of peasant life. One of the first American painters to specialize in scenes of Breton peasants, Wylie was soon followed by others including Henry Mosler (see cat. no. 38) and Burr H. Nicholls (see cat. no. 39).

*The Postman* is typical of Wylie's peasant scenes, serious in mood and somber in color. It depicts a family group, dressed in traditional Breton costume, gathered to listen while the postman reads a letter aloud. The dark interior setting with its dramatic highlights is similar in approach to Robert Koehler's scene of a German peasant reading (cat. no. 40). Literacy, whether it relates to European or American rural life (see cat. nos. 22 and 23) was a favorite narrative theme throughout the nineteenth century.

REFERENCE:

David Sellin, *Americans in Brittany and Normandy, 1860-1910*, exhib. cat., Phoenix: Phoenix Art Museum, 1982, pp. 11-30.

HENRY MOSLER
1841-1920

38. *The Rainy Day*, ca. 1880
Oil on canvas
36½ x 29⅛ in. (92.7 x 74 cm)
Gift of Joseph E. Temple, 1884.1.1

Henry Mosler began his artistic career as an illustrator, providing comic drawings for a popular magazine, *Omnibus*, and Civil War scenes for *Harper's Weekly*. In 1863 he went abroad for three years to study at the Royal Academy in Düsseldorf and then on to Paris before returning to his home in Cincinnati. Although he was a well-established painter of genre scenes and portraits by the mid-1870s, Mosler traveled to Europe again in 1874 for further studies in Munich and Paris, where he lived for the next fifteen years. A frequent exhibitor at the Paris Salons between 1878 and 1897, Mosler produced numerous genre scenes of French peasant life and a set of paintings about native-American customs.

*The Rainy Day* is characteristic of a Salon painter's approach to narrative genre painting and, like the work of Burr H. Nicholls (see cat. no. 39), is a rather sentimental scene of peasant life in Brittany. In Mosler's painting, two girls dressed in Breton costume seek refuge from the rain under a large umbrella. The figures are framed in the doorway of a farmhouse with a still-life arrangement placed on a windowsill to the left. By focusing on the sweetness of the children's expressions and the protective gesture of the older child, Mosler gives this work narrative content and creates a sentimental bond between his subject and the viewer. In spite of the drabness of the rainy day and perhaps even of their lives, these children are painted in rosy colors that reveal the artist's romanticized view of peasant life.

REFERENCES:

Natalie Spassky et al., *American Paintings in the Metropolitan Museum of Art: A Catalogue of Works by Artists Born between 1816 and 1864*, vol. 2, New York: Metropolitan Museum of Art, 1985, pp. 563-564.

Lois Marie Fink, *American Art at Nineteenth-Century Paris Salons*, Washington, D. C.: Smithsonian Institution Press, 1990, pp. 373-374.

GILDED AGE FANTASIES

BURR H. NICHOLLS
1848-1915

39. *Sunlight Effect*, 1881-82
Oil on canvas
51 ¹³⁄₁₆ x 41 ¹³⁄₁₆ in. (131.6 x 106.2 cm)
Gift of Joseph E. Temple, 1883.2

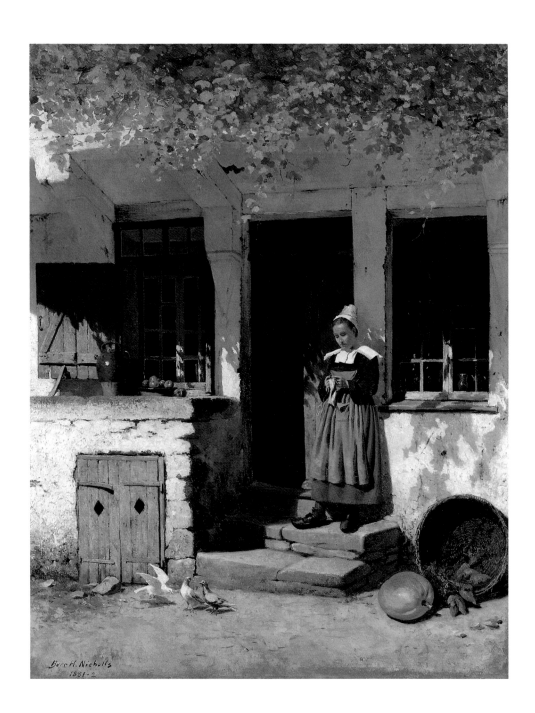

ROBERT KOEHLER
1850-1917

40. *A Holiday Occupation*, 1881
Oil on canvas
37⁷⁄₁₆ x 32¾ in. (95.1 x 83.2 cm)
Gift of Joseph E. Temple, 1882.2

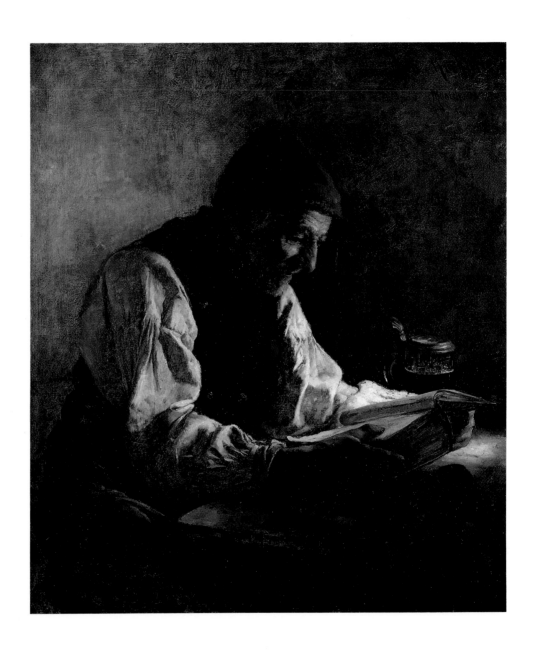

39. *Sunlight Effect*, 1881-82
Oil on canvas
51 13/16 x 41 13/16 in. (131.6 x 106.2 cm)
Gift of Joseph E. Temple, 1883.2

Burr H. Nicholls's painting describes more than just the physical effects of sunlight. The sense of harmony and well-being in this image of a young Breton girl provides an idealized view of French peasant life in the late nineteenth century. Although the peasants who fished and farmed on the remote coast of Brittany were among the poorest of the French lower classes, they had long appealed to French artists as picturesque subjects. Sophisticated academic figure painters were attracted by the quaint, traditional costumes of the Breton peasants and by what they, as city-dwellers, saw as a noble, rural way of life governed by nature. In the 1880s, Nicholls and other American artists who first trained in the academic studios of Paris congregated in the small village of Pont-Aven on the Brittany coast to learn to paint outdoors. These artists, Henry Mosler (see cat. no. 38) and Thomas Hovenden (see cat. no. 30) among them, adopted a similar romanticized view of the French peasantry in which the physical hardships of their lives received little attention.

In this genre scene, Nicholls surrounds the figure of a neatly dressed peasant girl with still-life arrangements of fruits and vegetables and a leafy arbor overhead. These compositional elements provide the narrative focus of the work. The girl diligently engaged in needlework, the farm produce at her feet, and the warm sunlight that bathes the facade of the humble but substantial farmhouse suggest the simple pleasures and rewards of life in the country. The girl's picturesque Breton costume, with its characteristic white peaked cap, broad starched collar, and wooden work shoes, or sabots, would have identified the location of this scene for any knowledgeable American traveler. An escapist antidote to the rising industrialism and urbanism of the Victorian era, Nicholls's work appealed to a growing number of wealthy Americans who had the money and leisure time to travel abroad, such as Joseph E. Temple, who purchased this work and another Breton peasant scene by Henry Mosler.

REFERENCE:

David Sellin, *Americans in Brittany and Normandy*, exhib. cat., Phoenix: Phoenix Art Museum, 1982, p. 154.

40.   *A Holiday Occupation*, 1881
Oil on canvas
37⁷⁄₁₆ x 32³⁄₄ in. (95.1 x 83.2 cm)
Gift of Joseph E. Temple, 1882.2

Robert Koehler was a German-born artist who immigrated to Milwaukee as a child. He began his artistic career as a printmaker in New York, while studying at the National Academy of Design and the Art Students League. In 1873 he returned to Germany to study at the Royal Academy in Munich. There he was very much influenced by the dark-toned, realist style espoused by his academic teachers. *A Holiday Occupation* typifies their approach to genre painting in its choice of a German peasant subject, predominant use of brown tonalities, and bright contrasts of light that highlight key compositional elements – the old man's weathered face and his weighty book.

The hardships of rural life, conveyed by the peasant's furrowed brow and thick, rough hands, were noted by a contemporary critic who praised this scene. "An old peasant man, bronzed with outdoor toil, sits pouring over the sacred page. In conception and technic the work is masterly" (*National Baptist*, Nov. 24, 1881). Dramatically illuminated from above with divine light, the peasant's book was clearly understood to be the Bible. Such images of devout peasants, reading, at prayer, or singing in church, were favorite subjects of the late-nineteenth-century genre painters who exhibited at the Paris Salons and inter-national expositions in both Europe and the United States. Koehler's painting and other similar works reaffirmed the hopes of wealthy art patrons that the peasantry still held on to old religious values regardless of the poverty and alienation they experienced as the result of rapid industrialization during the late nineteenth century.

REFERENCES:

Annette Blaugrund et al., *Paris 1889: American Artists at the Universal Exposition*, Philadelphia: Pennsylvania Academy of the Fine Arts, 1989, pp. 179-181.

Peter Hastings Falk, ed., *The Annual Exhibition Records of the Pennsylvania Academy of the Fine Arts, 1876-1913*, Madison, Ct.: Sound View Press, 1988, p. 289.

DANIEL RIDGWAY KNIGHT
1839-1924

41. *Hailing the Ferry,* 1888
Oil on canvas
64½ x 83⅛ in. (163.8 x 211.1 cm)
Gift of John H. Converse, 1891.7

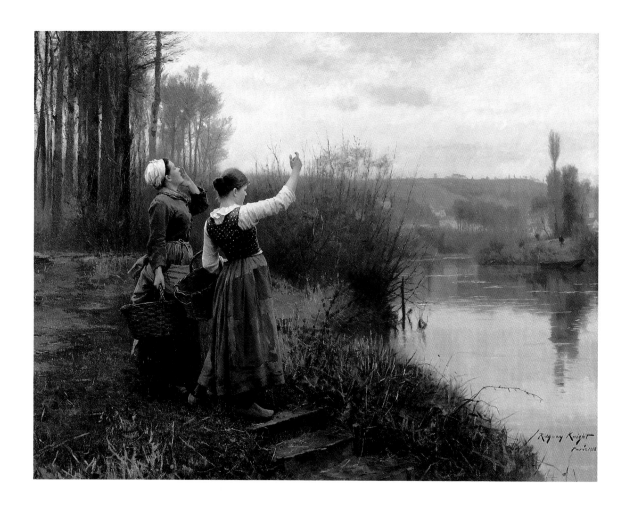

ANNA ELIZABETH KLUMPKE
1856-1942

42.   *In the Wash-House*, 1888
Oil on canvas, mounted on wood
79 x 67 in. (200.7 x 170.2 cm)
Gift of the artist, 1890.1

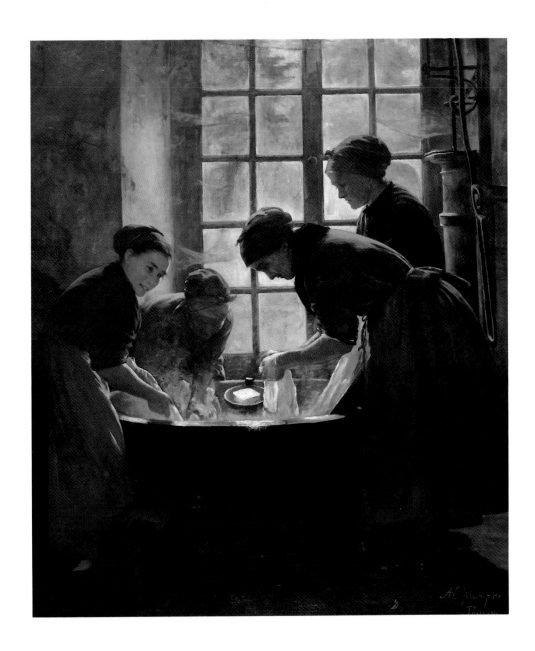

41.  *Hailing the Ferry*, 1888
Oil on canvas
64 ½ x 83 ⅛ in. (163.8 x 211.1 cm)
Gift of John H. Converse, 1891.7

Daniel Ridgway Knight's idealized paintings of French peasants were among the most popular genre subjects shown at the annual exhibitions at the Paris Salon; and they found a ready audience in Philadelphia, as well. *Hailing the Ferry* and another work by Knight entitled *Wayside Gossips* (possibly a painting entitled *The Gossips*, ca. 1885, Pennsylvania Academy of the Fine Arts) were shown at the Academy in the 1880s and purchased by a local collector, John H. Converse. Usually depicted at ease in a bucolic landscape, Knight's peasants seem wholly satisfied with their agrarian way of life. To a contemporary critic, Knight described his subjects as hard-working entrepreneurs who took joy in the natural world. "These peasants are as happy and content as any similar class in the world. They all save money and are small capitalists and investors....They love their native soil. In their hours of ease they have countless diversions; and the women know [how] to be merry in their hours of toil" (quoted in George Sheldon, *Recent Ideals of American Art*, New York: D. Appleton and Co., 1889, pp. 24-25).

Born in Philadelphia, Knight attended the Pennsylvania Academy between 1858 and 1861. In the early 1860s, he continued his studies in Paris at the Ecole des Beaux-Arts, where he expanded his skills as a figure painter. He also became friends with the French impressionist painters Alfred Sisley and Pierre-Auguste Renoir, who shared with Knight a love of the French countryside and peasant subjects. Having returned home to fight in the Civil War, Knight began his mature career as an artist specializing in narrative subjects drawn from his wartime experiences and his academic background. Literary themes from Shakespeare, the Bible, and classical history were among the first works that he exhibited in Philadelphia.

The lure of France proved to be strong, however, and in 1871 Knight moved back to Paris. He purchased a large country house in Poissy, just outside the city, so that he could be near his mentor, the French realist painter Jean-Louis-Ernest Meissonier. Applying Meissonier's meticulously detailed approach to the rendering of narrative subjects, Knight found his own theme in depictions of neighboring peasants who worked along the Seine River. He bought old clothes from local villagers to dress his models and often posed them in such a way as to evoke classical statuary, creating an effect that seems rather staged and even artificial to modern eyes. To a late-nineteenth-century audience, however, Knight's peasant fantasies preserved a fast-disappearing way of rural life; and *Hailing the Ferry* has proved to be one of the most often copied paintings in the Pennsylvania Academy's collection.

REFERENCES:

Ridgway B. Knight, "Ridgway Knight: A Master of the Pastoral Genre," in *A Pastoral Legacy, Paintings and Drawing by the American Artists Ridgway Knight and Aston Knight*, exhib. cat., Ithaca, N.Y.: Herbert F. Johnson Museum of Art, Cornell University, 1989 (unpaginated).

Annette Blaugrund et al., *Paris 1889, American Artists at the Universal Exposition*, exhib. cat., Philadelphia: Pennsylvania Academy of the Fine Arts, 1989, pp. 179-180.

ANNA ELIZABETH KLUMPKE
1856-1942

42. *In the Wash-House*, 1888
Oil on canvas, mounted on wood
79 x 67 in. (200.7 x 170.2 cm)
Gift of the artist, 1890.1

This humble genre scene of French washer-women ennobles the subject by its large scale and poetic lighting. Klumpke first sketched these laundresses at the country home of the painter Felix de Vuillefoy. He encouraged Klumpke to paint the scene and to submit the finished work for exhibition at the Paris Salon of 1888. The subject proved popular with American audiences, as well, when it was shown at the Art Institute in Chicago that same year and the following spring in Philadelphia. It won a Temple Gold Medal for the best figure painting in the Pennsylvania Academy's annual exhibition of 1889. The manufacturer of Pears Soap offered to buy the work, probably to use as an advertisement for its product.

Klumpke's realist approach to figure painting developed from her early training at the Pennsylvania Academy and in Paris at the Académie Julian. In Paris, she became an ardent follower of Rosa Bonheur, the most distinguished female academic artist of the period. Bonheur eventually bequeathed her country estate near the Fontainebleau Forest to Klumpke, who remained in France for most of her career. Like other expatriate American artists with ties to Philadelphia, especially Daniel Ridgway Knight (see cat. no. 41) and Burr H. Nicholls (see cat. no. 39), Klumpke provided a cheerful view of the French peasantry and ignored the hardship of their lives. The realist style of these artists is limited to details of dress and setting. It does not to extend to the actual conditions of poverty and long working hours suffered by the rural and urban working class in the late nineteenth century.

REFERENCE:

Eleanor Tufts, *American Women Artists 1830-1930*, exhib. cat., Washington, D.C.: National Museum of Women in the Arts, 1987, cat. nos. 13 and 47.

43. *The Three Beggars of Cordova*, ca. 1891
Oil on canvas
66 x 98½ in. (167.6 x 250.2 cm)
Gift of Charles W. Wharton, 1892.5

Edwin Lord Weeks was an American-born painter who spent most of his life traveling throughout Europe, the Middle East, and India. His narrative subjects are based on his travels and focus on the distinctive architecture and peoples of these regions. The late nineteenth century gave rise to a number of European and American artists, like Weeks, who were called "orientalists" because they specialized in exotic travel subjects. Their work was often featured at international expositions held in major European capitals such as Paris, London, and Berlin. It appealed to a growing number of Americans who had financial and cultural interests abroad. In 1891 Weeks exhibited *The Three Beggars of Cordova* at the Paris Salon and at the Philadelphia Art Club exhibition, where it received a gold medal. The painting was also shown at the 1893 World's Columbian Exposition in Chicago, one of the most important international fairs of the century. Weeks was a frequent exhibitor at the Pennsylvania Academy, where he showed scenes of Morocco, Persia, and India.

This work, depicting three Spanish beggars resting on a sunny stone wall, was given to the Academy by a wealthy Philadelphia businessman and financier, Charles W. Wharton. When Weeks sent the painting to the Academy, he noted that it was "considered my finest work by the Spanish painters Bonnat, Madrazo, and Melida." The admiration of these artists, who surely would have recognized the national identity of his subject, was important to Weeks, as his art revolved around his ability to capture specific national and ethnic characteristics. Weeks's subjects, dressed in the dark clothing and broad-brimmed hats usually worn by Spanish beggars, are similar to the peasants popularized earlier in the century by impressionist painters, such as Edouard Manet and Mary Cassatt. By 1890 gypsies, bull fighters, guitar players, and beggars were well-recognized Spanish types. As in impressionist painting, there is no specific story associated with Weeks's image of the Spanish beggars, but their worn faces with weary but wise expressions and their shabby clothes can be associated with earlier depictions of ancient philosophers by seventeenth-century Spanish painters, such as Velázquez and Ribera.

REFERENCE:

D. Dodge Thompson, "Edwin Lord Weeks: American Painter of India," *Antiques* 128 (August 1985), pp. 246-257.

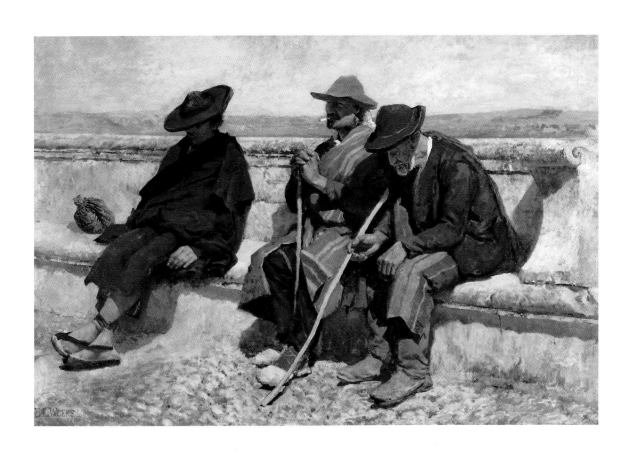

The entries in this catalogue provide a short list of references for each artist. The following books are useful for more general reading on nineteenth-century history and genre painting by American artists.

Abrams, Ann Uhry. *The Valiant Hero: Benjamin West and Grand-Style History Painting*. Washington, D.C.: Smithsonian Institution Press, 1985.

Blaugrund, Annette, et al. *Paris 1889: American Artists at the Universal Exposition*. exhib. cat., Philadelphia: Pennsylvania Academy of the Fine Arts, 1989.

Casteras, Susan P. *English Pre-Raphaelitism and Its Reception in America in the Nineteenth Century*. Rutherford, N.J.: Associated University Presses, 1990.

Evans, Dorinda. *Benjamin West and His American Students*. exhib. cat., Washington, D.C.: Smithsonian Institution Press, 1980.

Gerdts, William H., and Mark Thistlethwaite. *Grand Illusions: History Painting in America*. Fort Worth: Amon Carter Museum, 1988.

Goodyear, Frank H., Jr., et al. *In This Academy: The Pennsylvania Academy of the Fine Arts, 1805-1976*. exhib. cat., Philadelphia: Pennsylvania Academy of the Fine Arts, 1976.

Harding, Anneliese, and Brucia Wittoft. *American Artists in Düsseldorf: 1840-1865*. exhib. cat., Framingham, Ma.: Danforth Museum, 1982.

Hills, Patricia. *The Painter's America, Rural and Urban Life, 1810-1910*. exhib. cat., New York: Whitney Museum of American Art, 1974.

Hoopes, Donelson, and Nancy Wall Moure. *American Narrative Painting*. exhib. cat., Los Angeles: Los Angeles County Museum of Art, 1974.

McElroy, Guy C., et al. *Facing History: The Black Image in American Art, 1710-1940*. exhib. cat., Washington, D.C.: Corcoran Gallery of Art, 1990.

Onorato, Ronald. "The Pennsylvania Academy of the Fine Arts and the Development of An Academic Curriculum in the Nineteenth Century." Ph.D. diss., Brown University, 1977.

Quick, Michael, and Eberhard Ruhmer. *Munich and American Realism in the Nineteenth Century*. exhib. cat., Sacramento: E. B. Crocker Art Gallery, 1978.

Quick, Michael. *American Expatriate Painters of the Late Nineteenth Century*. exhib. cat., Dayton: Dayton Art Institute, 1976.

Truettner, William H. "The Art of History: American Exploration and Discovery Scenes, 1840-1860," *American Art Journal* 14 (Winter 1982), pp. 4-31.

Weinberg, H. Barbara. "The Lure of Paris, Late-Nineteenth-Century American Painters and Their French Training," in *A New World: Masterpieces of American Painting, 1760-1910*. exhib. cat., Boston: Museum of Fine Arts, 1983, pp. 16-32.

Herman Warner Williams. *Mirror of the American Past: A Survey of American Genre Painting, 1750-1900*, Greenwich, Ct.: New York Graphic Society, 1973.

# Index